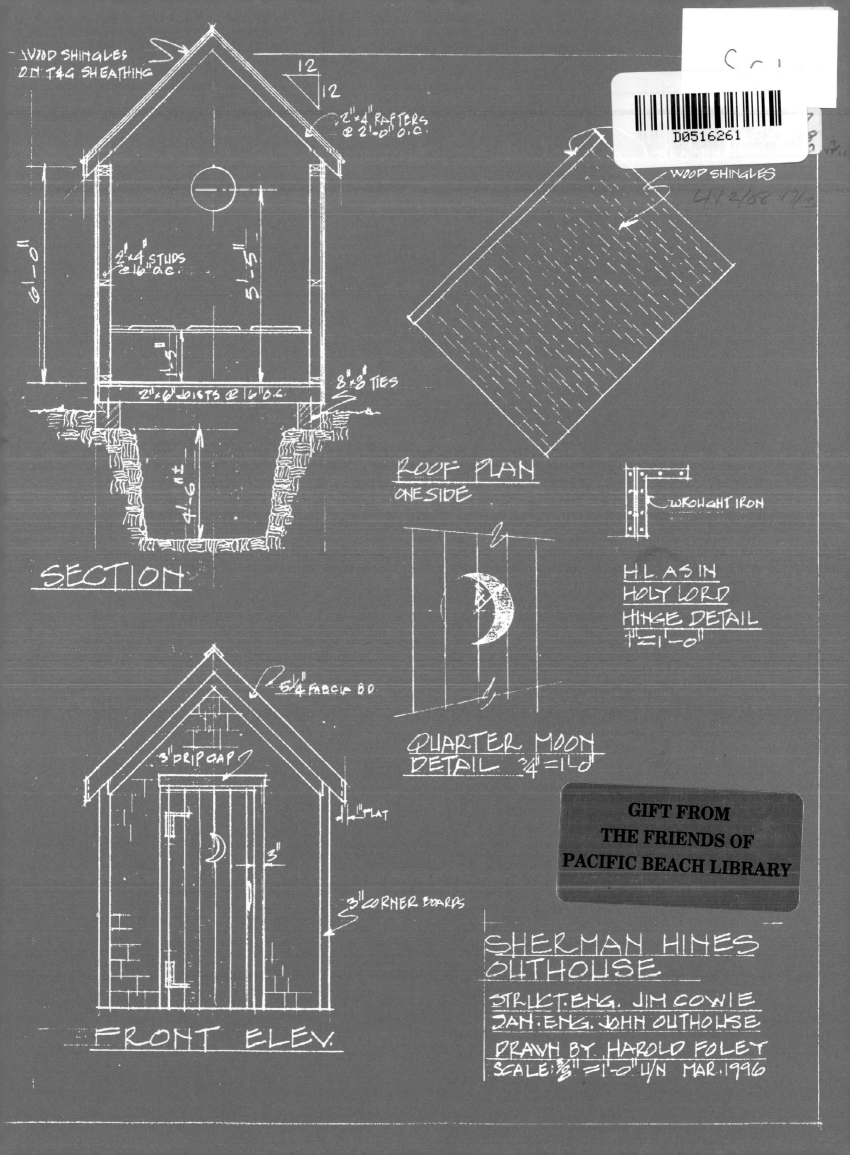

WOOD SHINGLES ON T&G SHEATHING

12 / 12

2"×4" RAFTERS @ 2'-0" O.C.

6'-0"

4"×4" STUDS @ 16" O.C.

5'-5"

1'-5"

2"×6" JOISTS @ 16" O.C.

8"×8" TIES

4'-6" ±

SECTION

ROOF PLAN
ONE SIDE

WOOD SHINGLES

WROUGHT IRON

H.L. AS IN
HOLY LORD
HINGE DETAIL 1"=1'-0"

QUARTER MOON
DETAIL ¾"=1'-0"

5¼" FASCIA BD

3" DRIP CAP

1" FLAT

3"

3" CORNER BOARDS

FRONT ELEV.

SHERMAN HINES
OUTHOUSE

STRUCT. ENG. JIM COWIE
SAN. ENG. JOHN OUTHOUSE
DRAWN BY HAROLD FOLEY
SCALE ⅜"=1'-0" U/N MAR. 1996

The Outhouse REVISITED

The Outhouse REVISITED

Photographs by Sherman Hines
Text by Don Harron

FIREFLY BOOKS

A FIREFLY BOOK

Photographs Copyright © 1996 Sherman Hines
Text Copyright © 1996 Don Harron

Second printing 1997.

Cataloguing in Publication Data

Hines, Sherman, 1941 -
 The outhouse revisited

ISBN 1-55209-062-0

1. Outhouses - Pictorial works. I. Harron, Don, 1924 -
II. Title.

TD775.H55 1996 628'.742 C96-930943-0

Readers who want more information are invited to write to:
The Outhouse Preservation Society
Box 25012
Halifax, N.S.
B3M 4H4 Canada

Published by
Firefly Books Ltd.
3680 Victoria Park Avenue
Willowdale, Ontario
Canada M2H 3K1

Published in the U.S. by
Firefly Books (U.S.) Inc.
P.O. Box 1338, Ellicott Station
Buffalo, New York 14205

Book Design: Fortunato Aglialoro
 Falcom Design & Communications Inc.

Printed and bound in Canada by
Friesens
Altona, Manitoba

Preface

When did civilization as we know it begin on this earth of ours? Some might say it was with the invention of fire. But fire wasn't invented by humankind; it already existed in nature. Primitive humans learned to create heat for themselves by rubbing two objects together, in the same manner as they had first created warmth in their sexual relations.

Some historians felt that it was the invention of the wheel that civilized our species, and separated humans from animals. I suppose it made a man more mobile than an animal, although it took thousands of years for him to exceed the speed of the cheetah that chased him. In any case that sort of locomotion has simply meant that we are still going round in circles without any appreciable increase in our brain power.

The idea of personal privacy could be more important to civilization than the invention of the wheel. Perhaps the wheel itself was invented by some primeval Pithecanthropus Erectus who found a place to sit and think and let those wheels go around in his head first.

Many anthropologists feel that man differentiated himself from the animals when he got up off all fours and stood erect.

My own feeling is that we started to acquire the veneer of civilized society when we sat down. This occurred either by sharing a meal with our family, which marked the beginning of the art of conversation, or by sitting alone in the sanctity of some secret place dedicated to the movement of our bowels.

It was the latter ritual that was more conducive to the art of contemplation. Here, in my opinion, is where thought was born. Ever since the first Cro-Magnon man was told by his

woman to curb his natural instincts and do it outside the cave, mankind has sought some kind of sanctuary where he can be alone with his thoughts.

Perhaps, at first, he simply held on for dear life to the branch of a bush or tree overlooking a steep cliff, and let the law of gravity do the rest. (If, indeed, that law had been passed by that time.) But eventually humankind sought some small place that would give a kind of spiritual solace to the act of defecation. There would be no room for those huge cave drawings depicting where the deer and the antelope play. But the seated solution to this primitive function, and the thoughts it engendered, could have heralded the beginnings of the art of writing. Grabbing at papyrus stalks in a frantic emergency could have led to the more comfortable notion of paper.

The best known statue in the Western world is Rodin's "The Thinker." We don't know what this man was thinking about, but in his seated position we have a pretty good idea where he was doing it. Some of the greatest ideas of all time have occurred in this particular place. Perhaps here is where Albert Einstein brought us the notion of the fourth dimension, which enabled us to begin to comprehend on a regular basis the gaping hole of the abyss that we all must face. The founder of modern philosophy is acknowledged to be René Descartes. Where do you think he was when he formulated his great thesis: "I stink, therefore I am"?

Who knows at what age the first outhouse appeared? Probably well before the Iron Age, more likely during the Wood Age. All you needed were a few round pegs in square holes to keep the thing together. Whoever designed the first one has the enduring gratitude of all of us. To quote the Bard of Avon, (Hamlet, Act I, scene 1): "For this relief, much thanks!"

DON HARRON

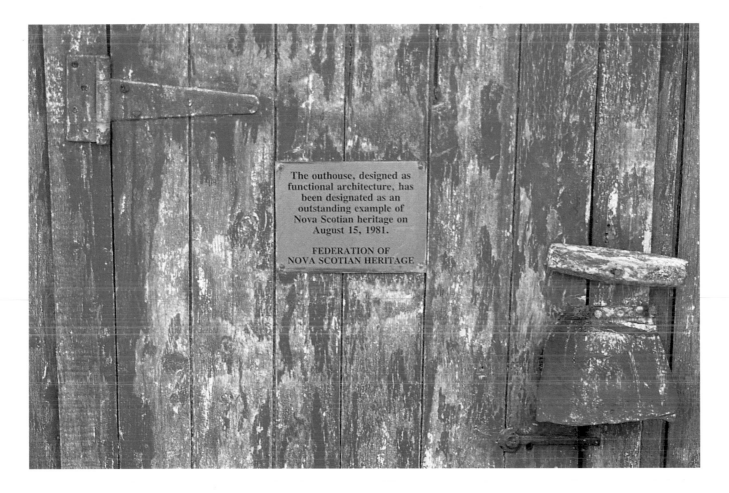

The outhouse, designed as functional architecture, has been designated as an outstanding example of Nova Scotian heritage on August 15, 1981.

FEDERATION OF NOVA SCOTIAN HERITAGE

A remembrance of things passed.

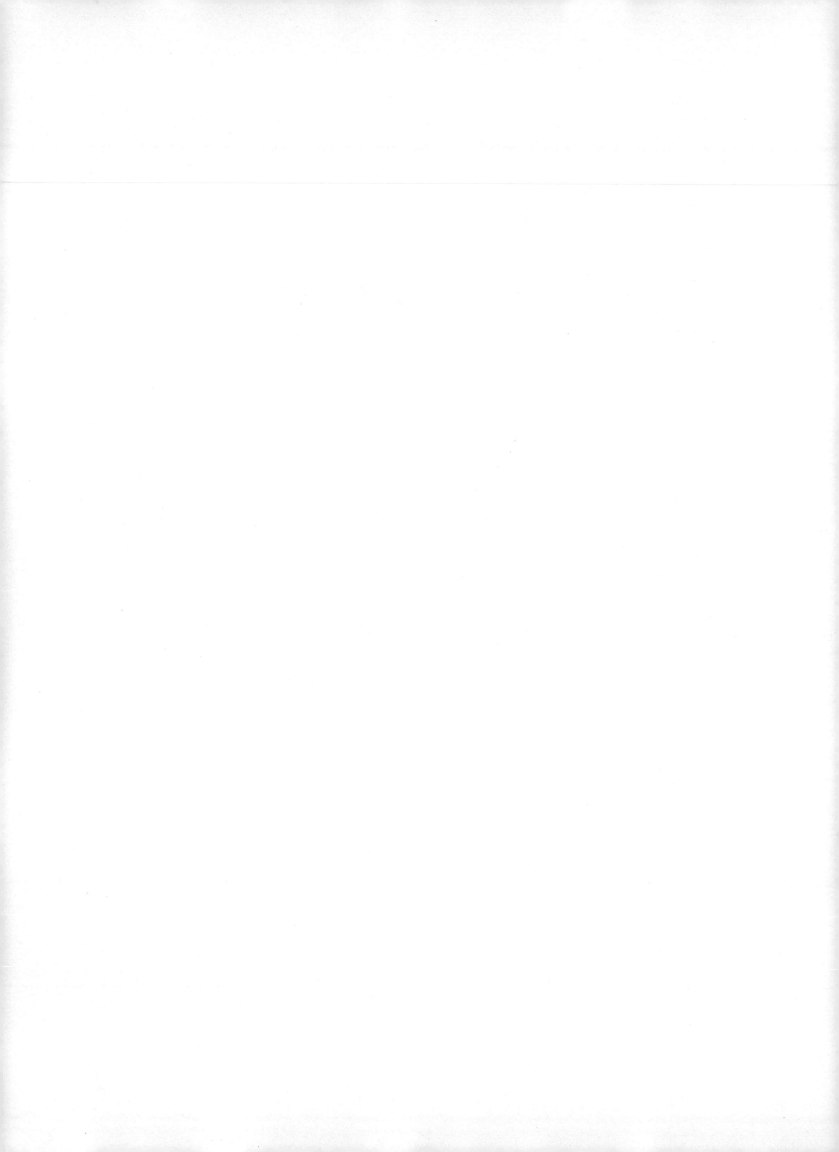

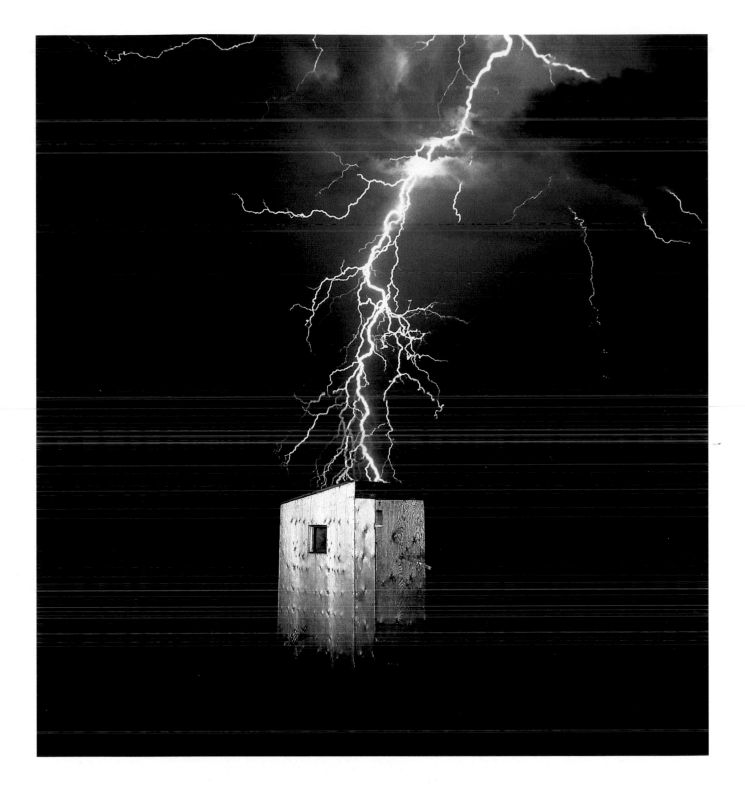

Thunder is impressive,
but it is lightning that does the work.
— *Mark Twain*

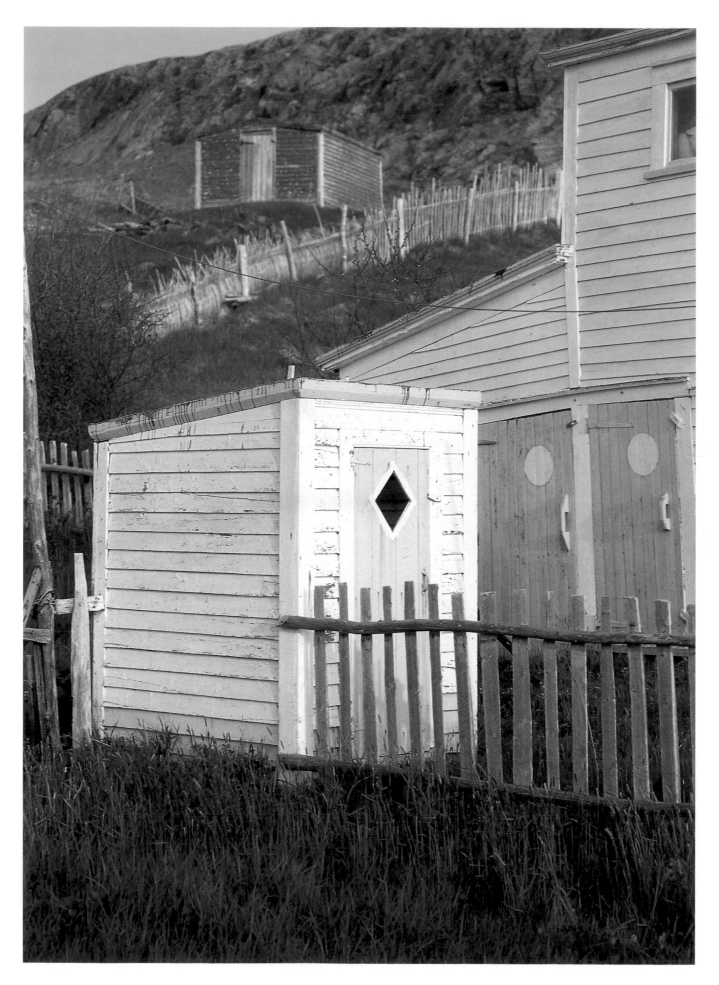

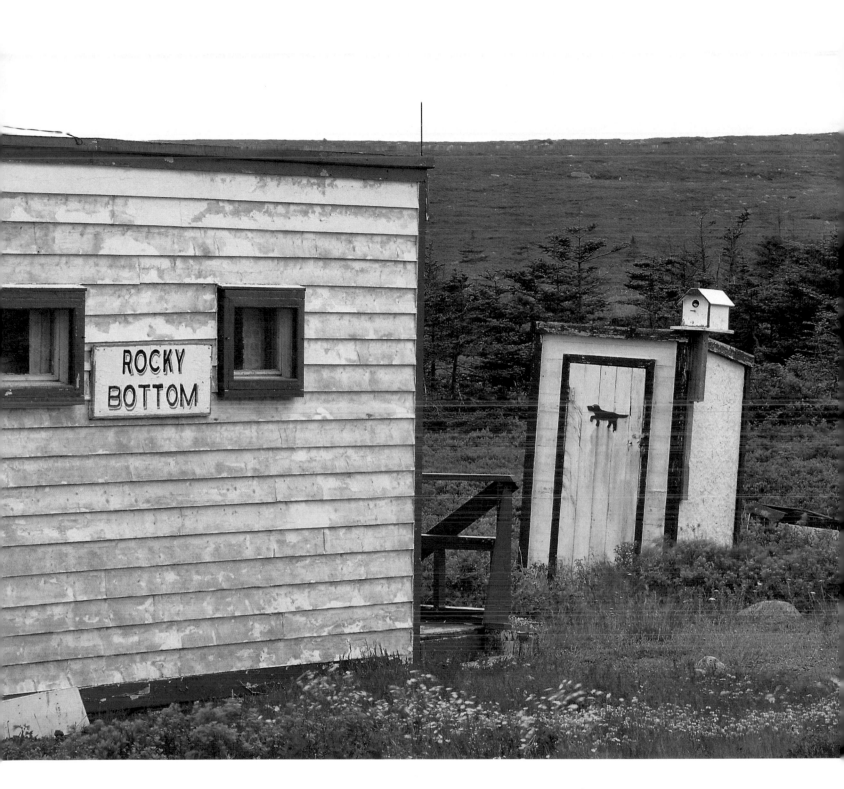

Where there is no alternative, you have to make the hard choice.

◁ A diamond in the rough.

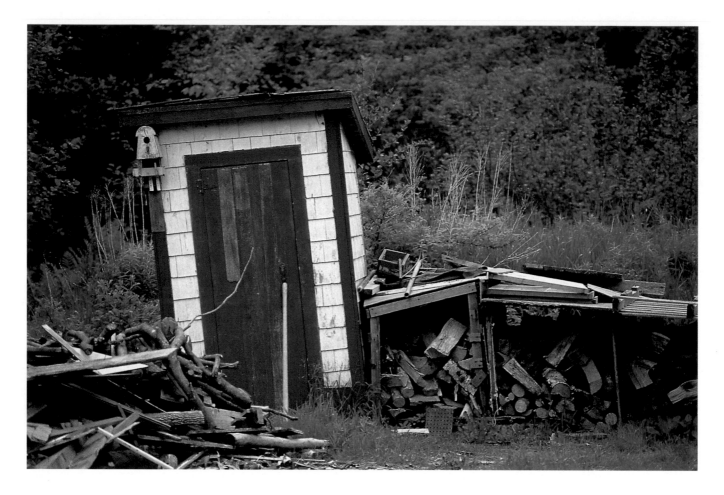

A few chips off the old block in case you run out of catalog.

Laidback, out back. ▷

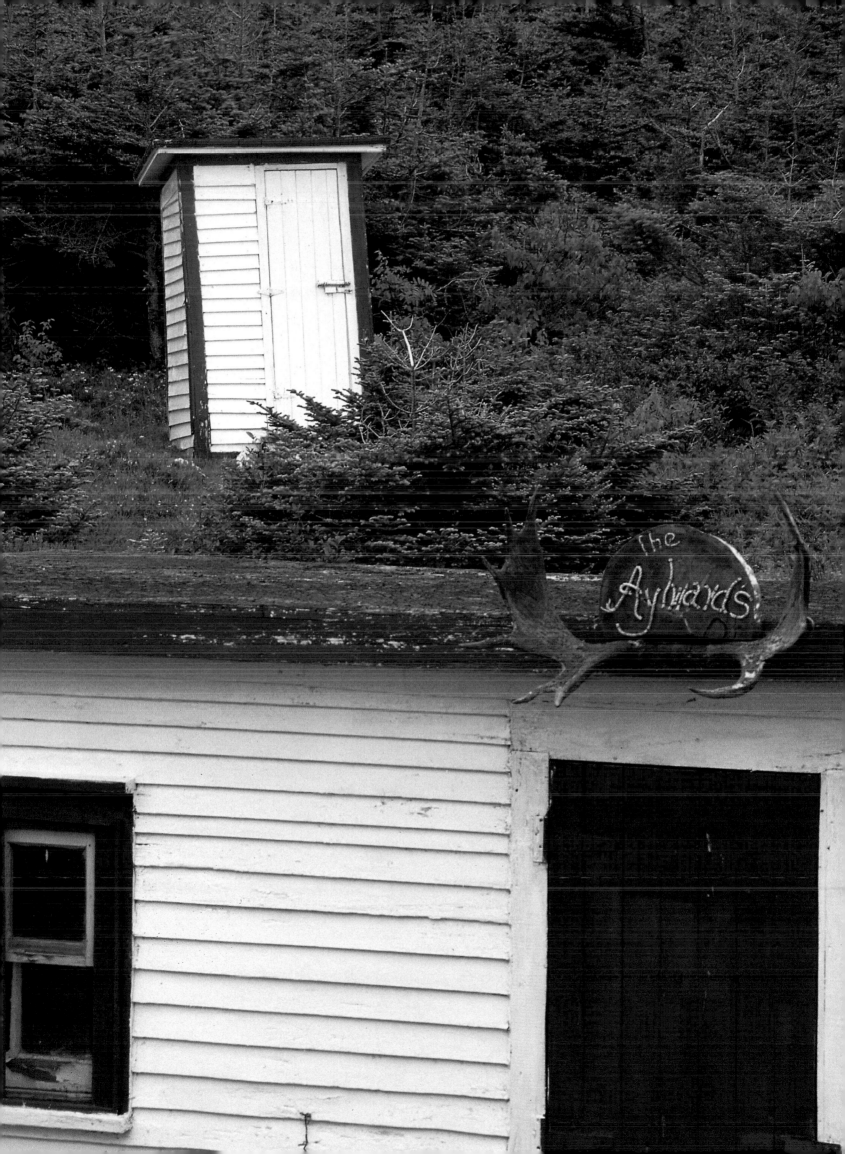

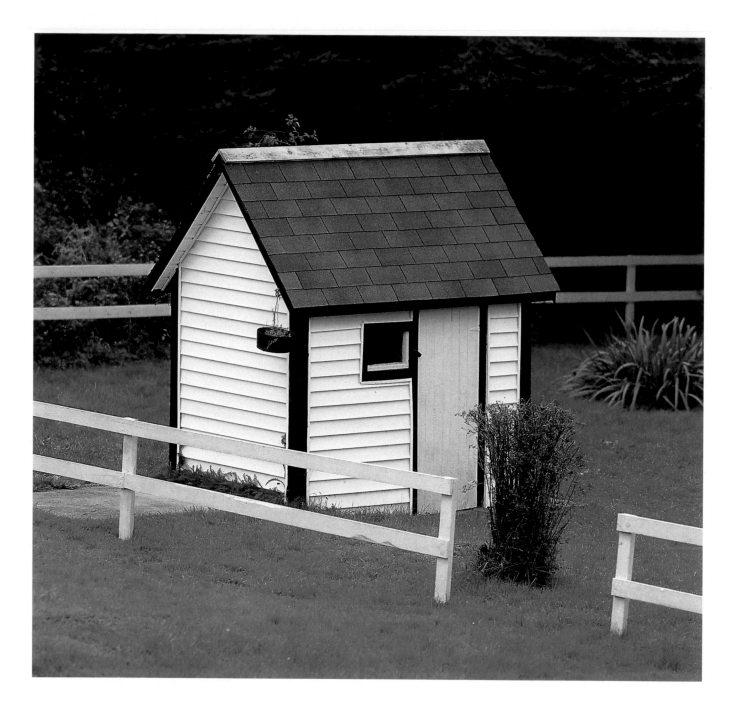

A pleasant county seat.

Shared pasture. ▷

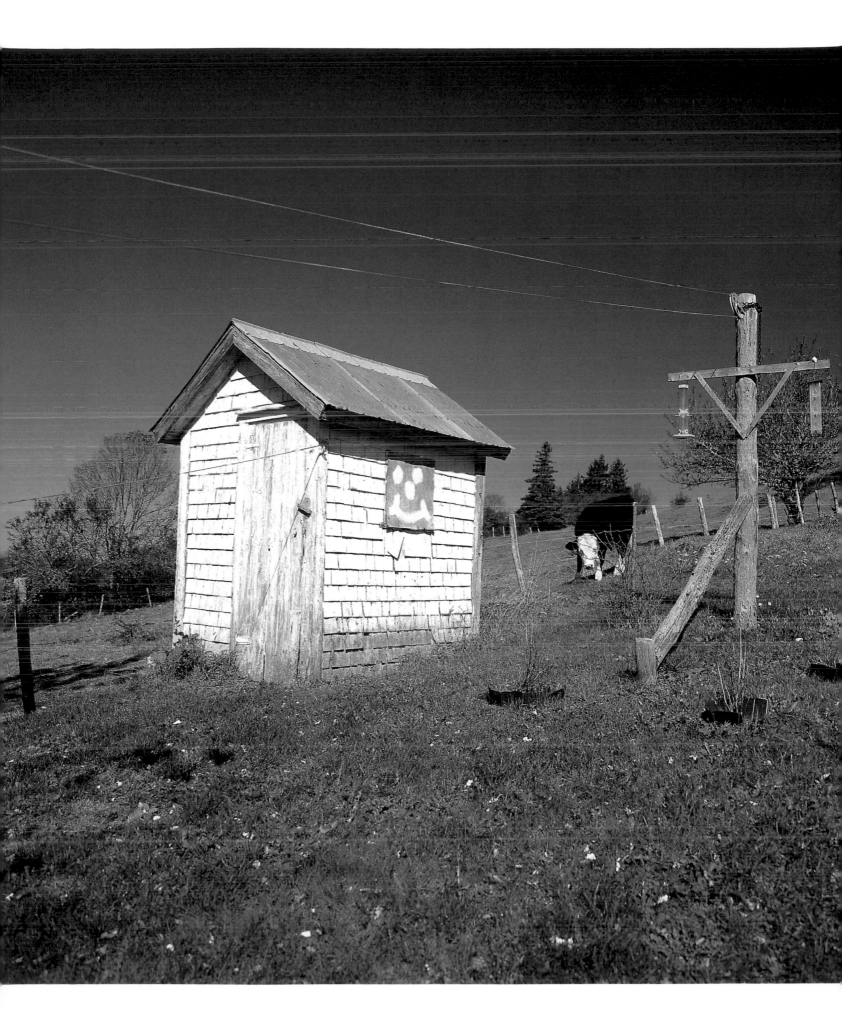

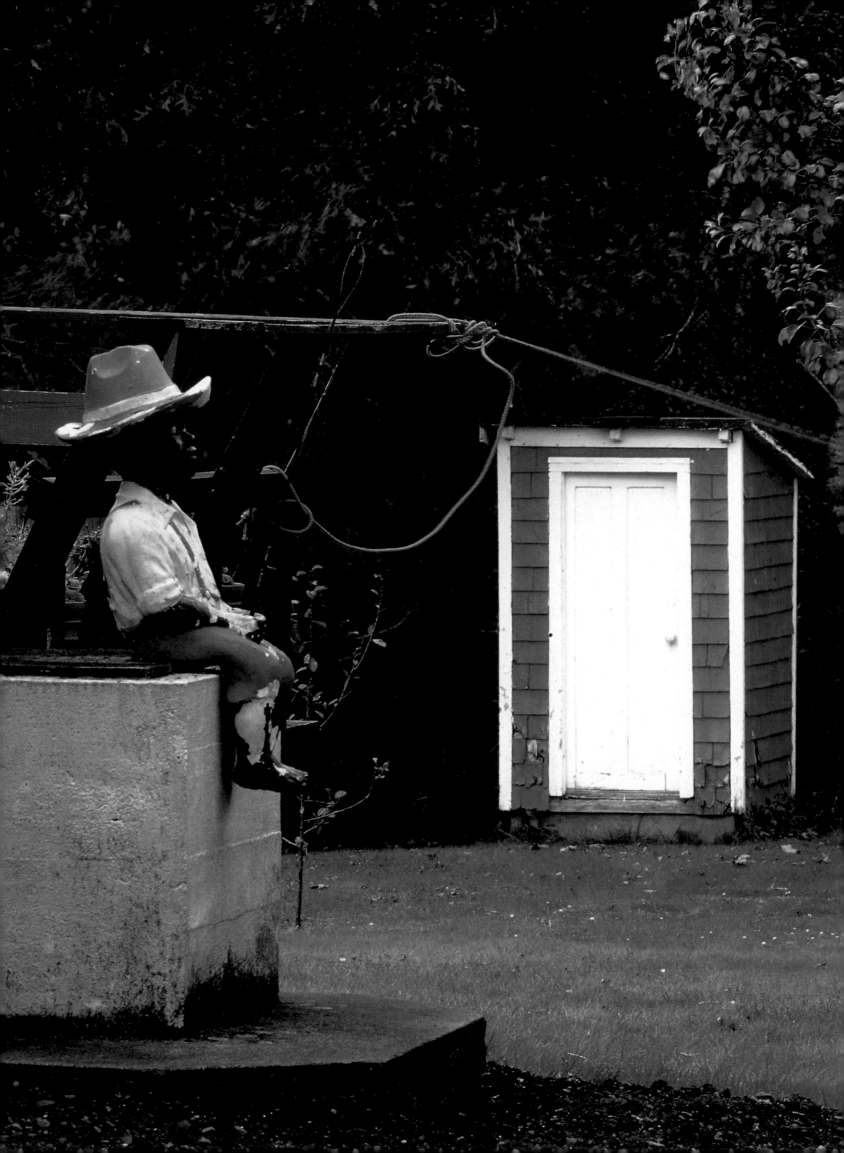

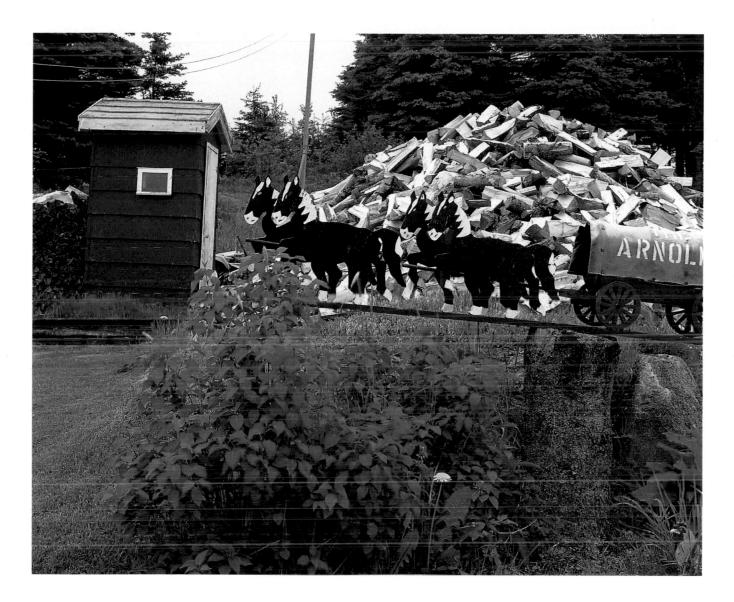

Two loads a day keeps the wood box full.

◁ All's well that ends on the well.

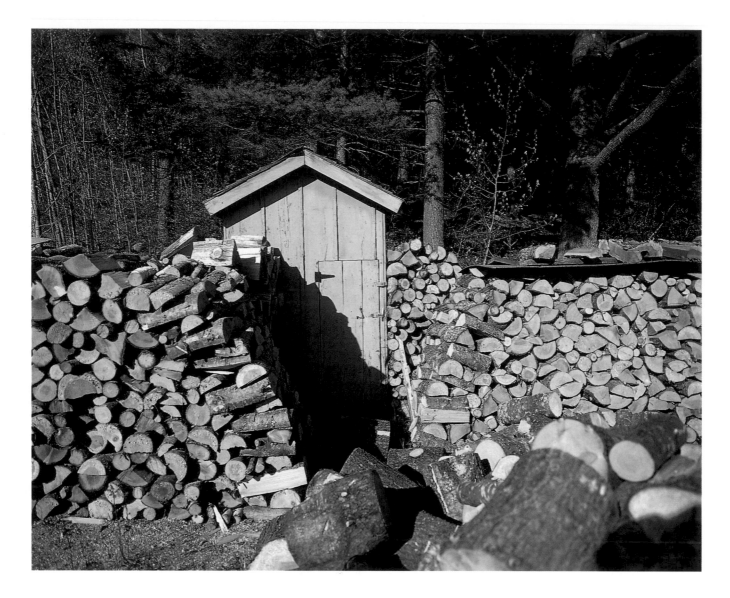

Just grab a few sticks for the fire on your way back.

The little house has a big heart. ▷

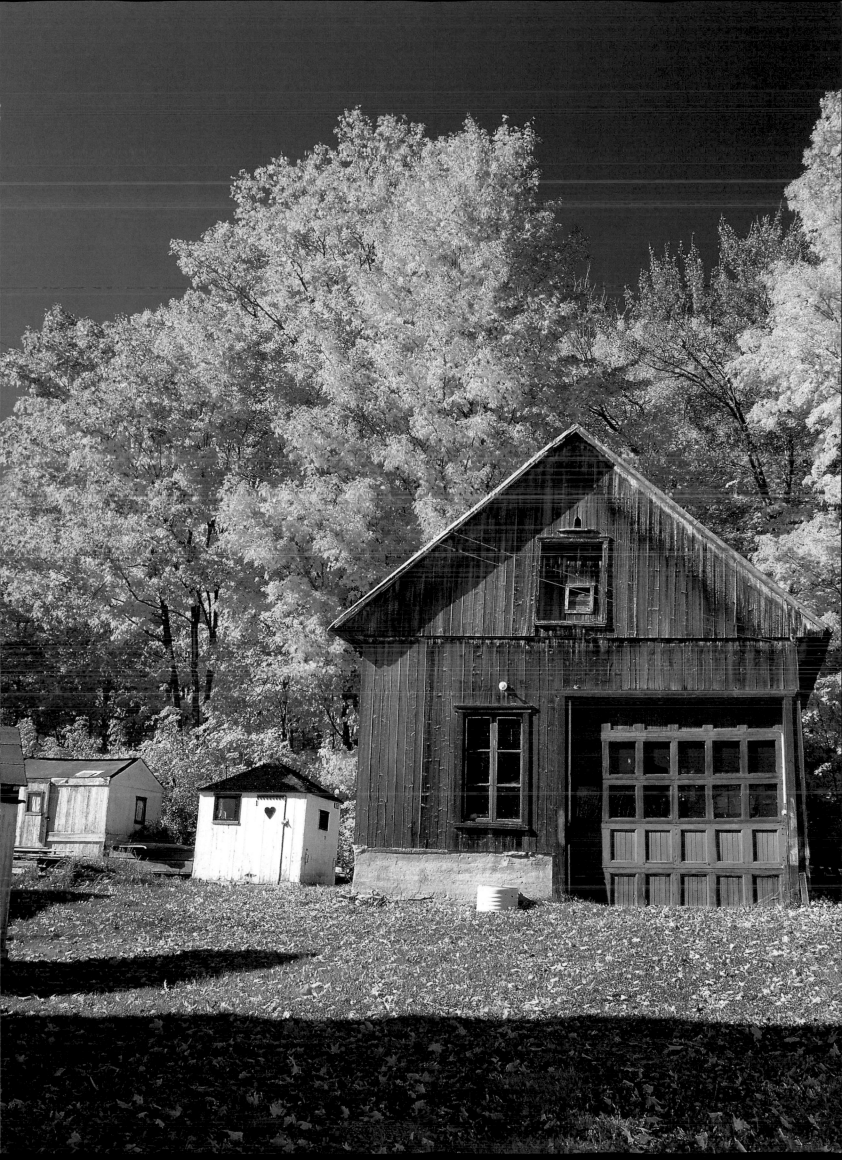

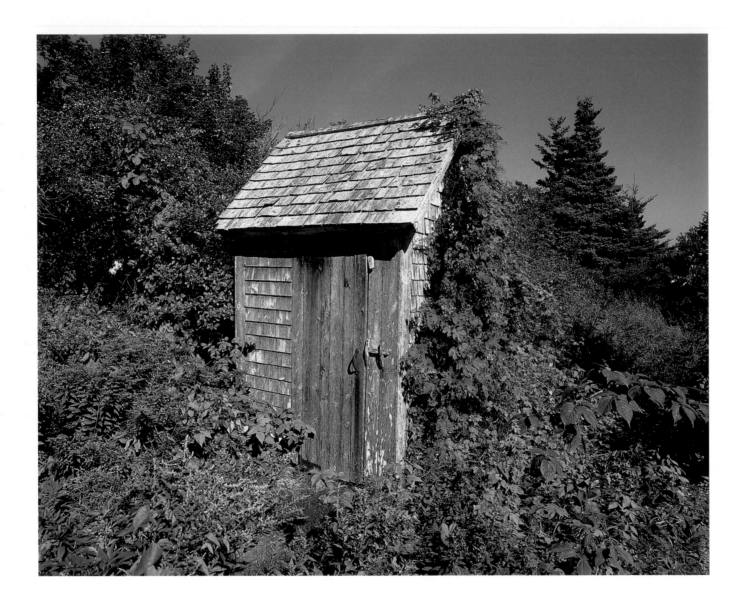

Funny how well things seem to grow around here.

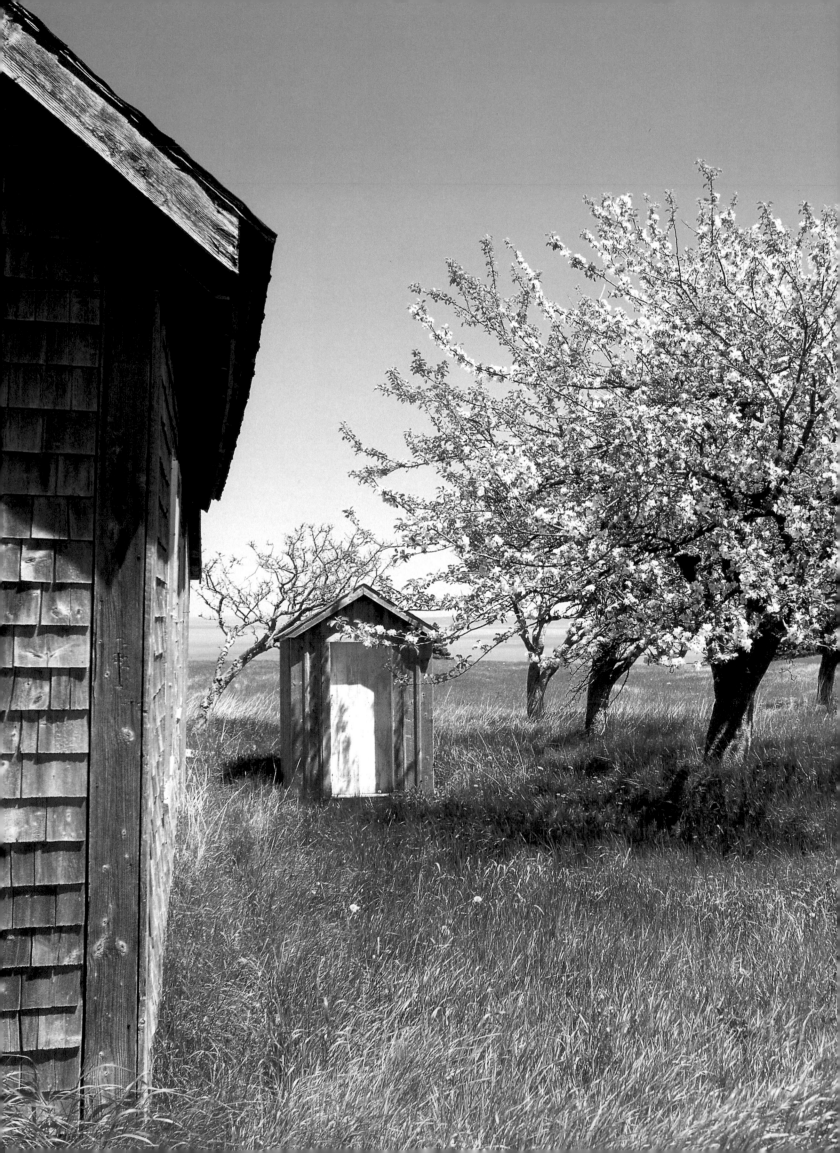

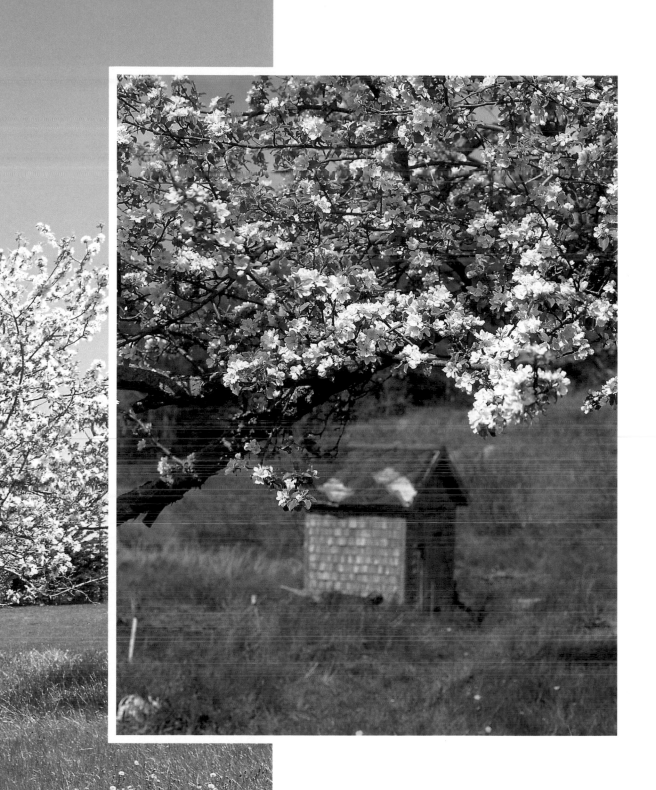

We sit surrounded by the sweet
and fragrant smells of spring.

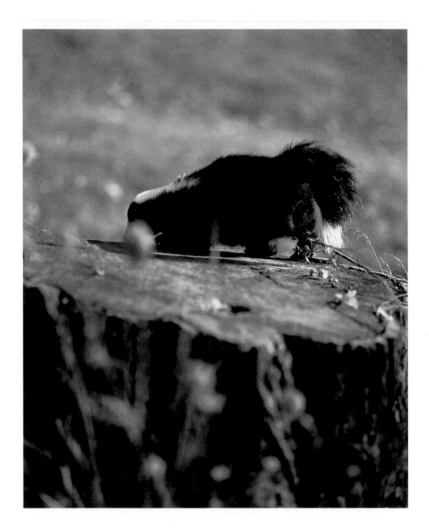

Duck!

Don't sit there mooning! ▷

(overleaf) We ducked in ahead of the crowd
and ducked out again.

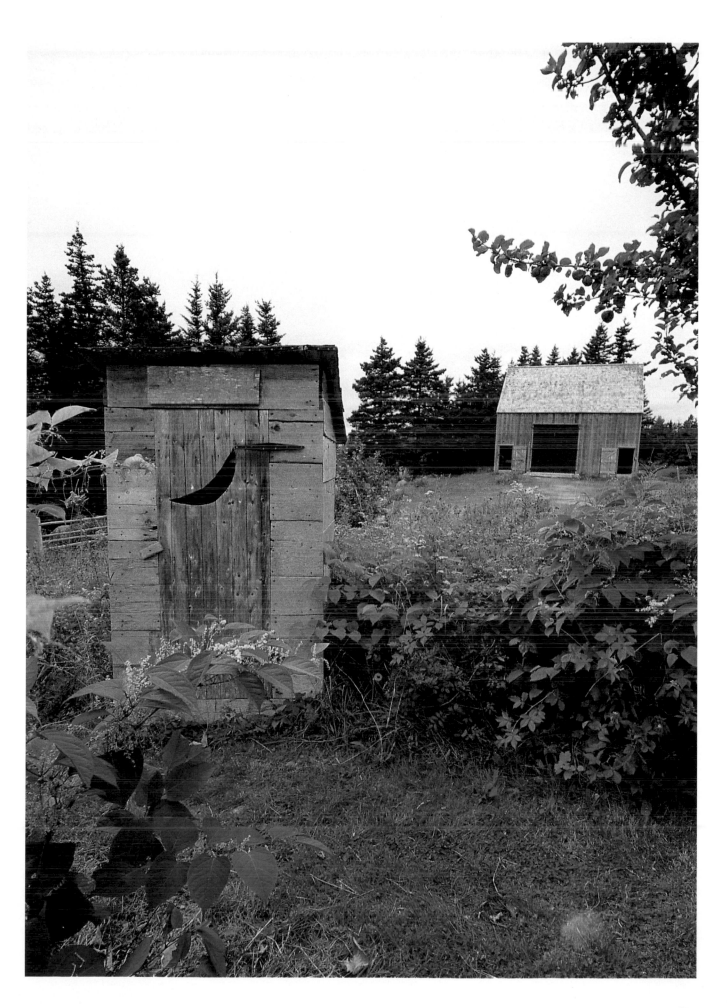

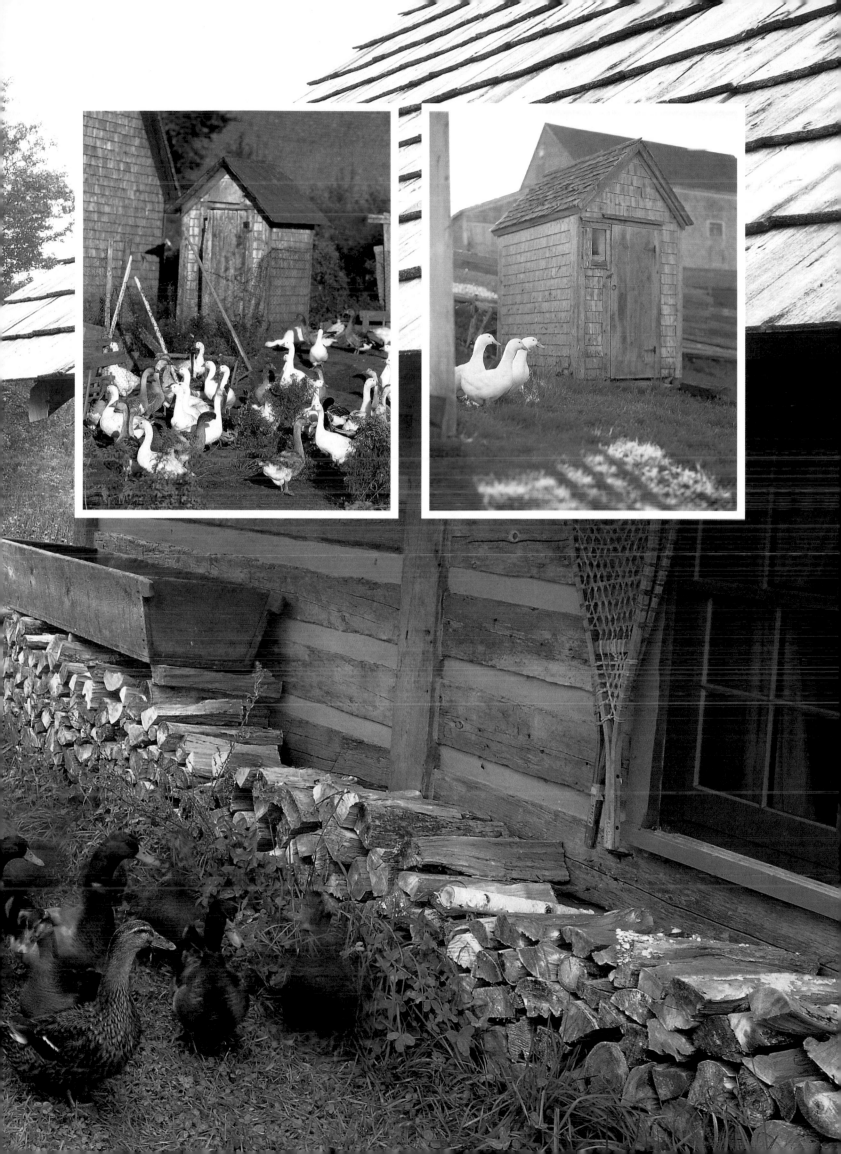

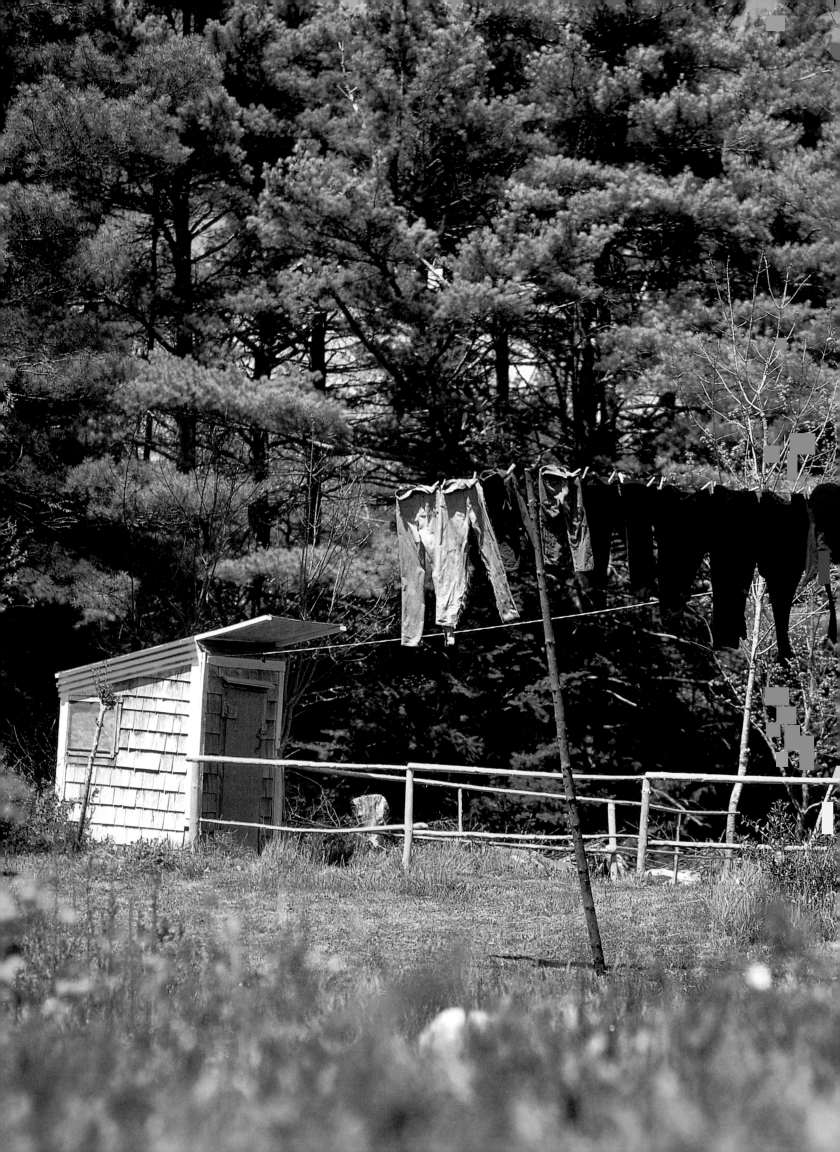

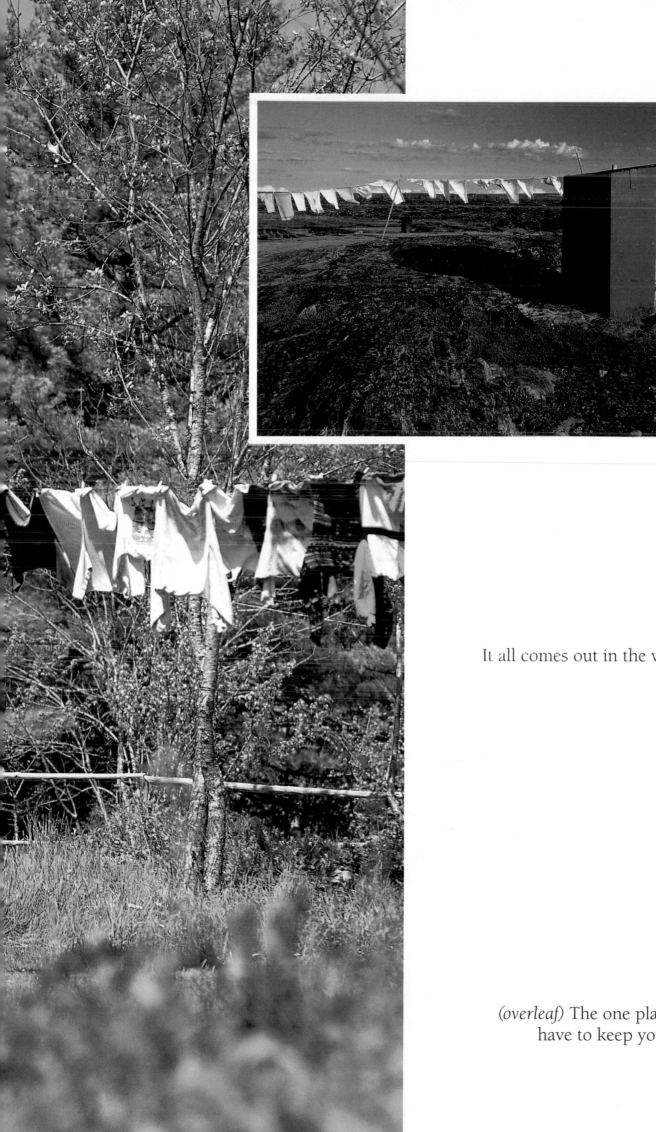

It all comes out in the wash.

(*overleaf*) The one place you don't
have to keep your trap shut.

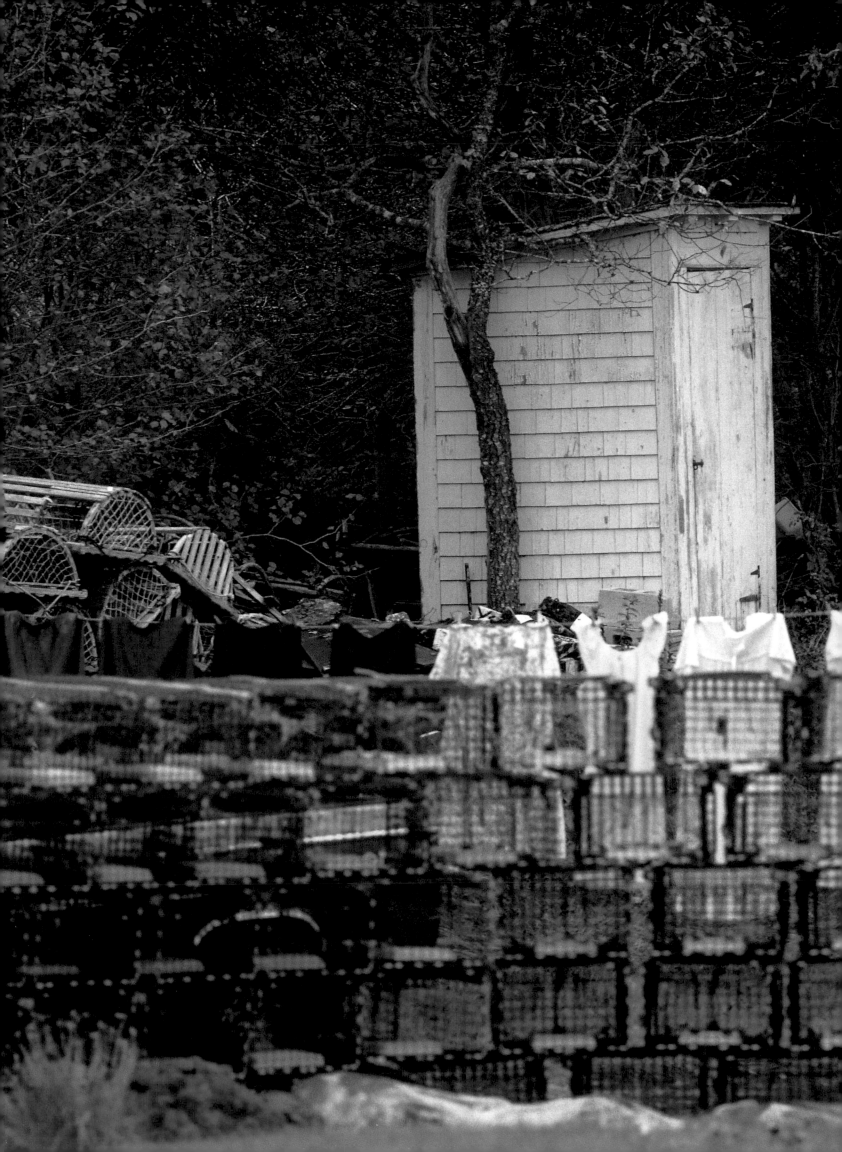

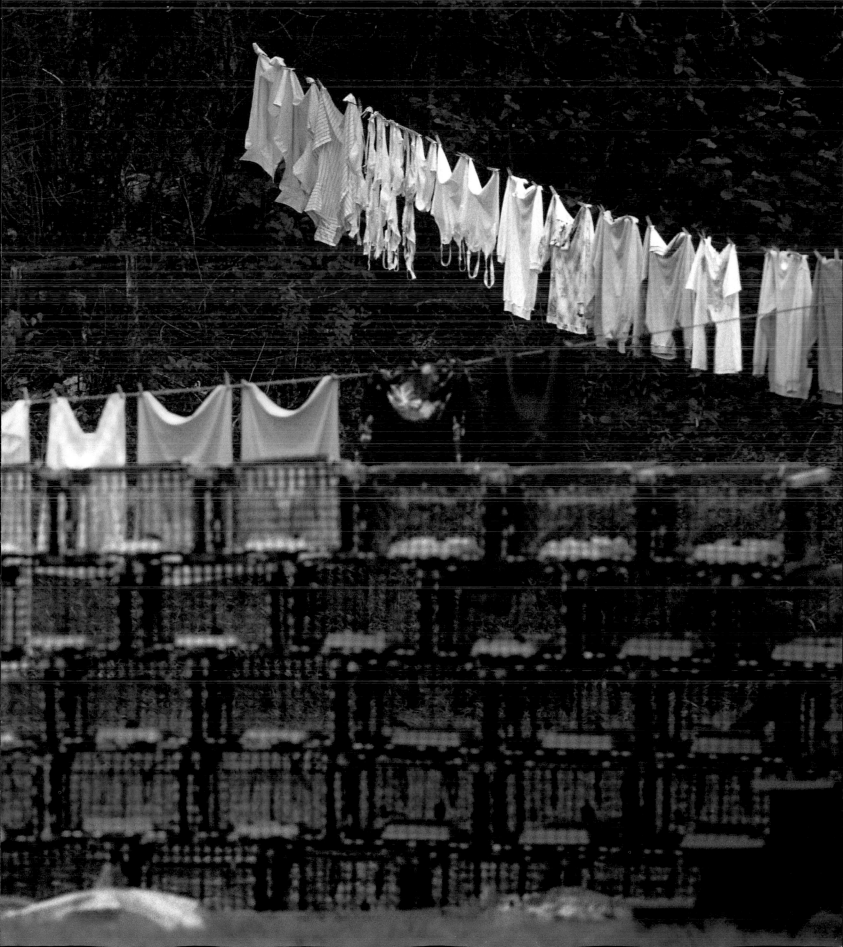

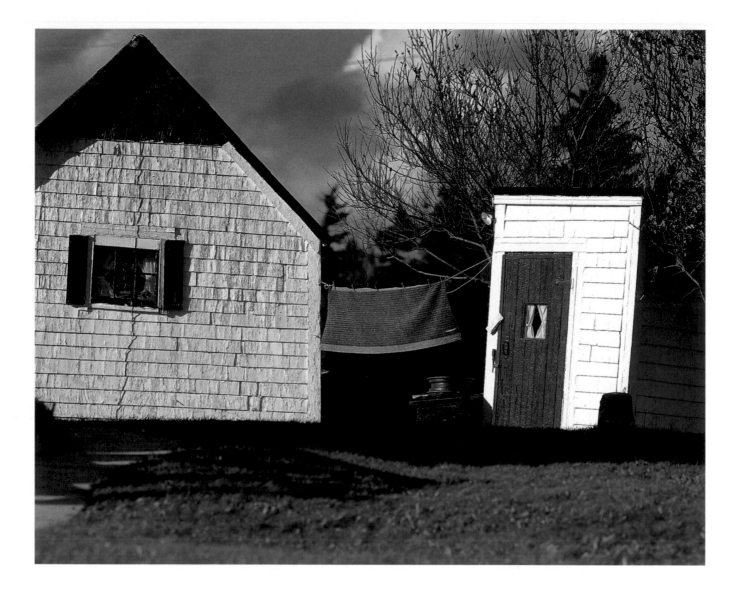

You may want to take a chance on a blanket but it's curtains for you.

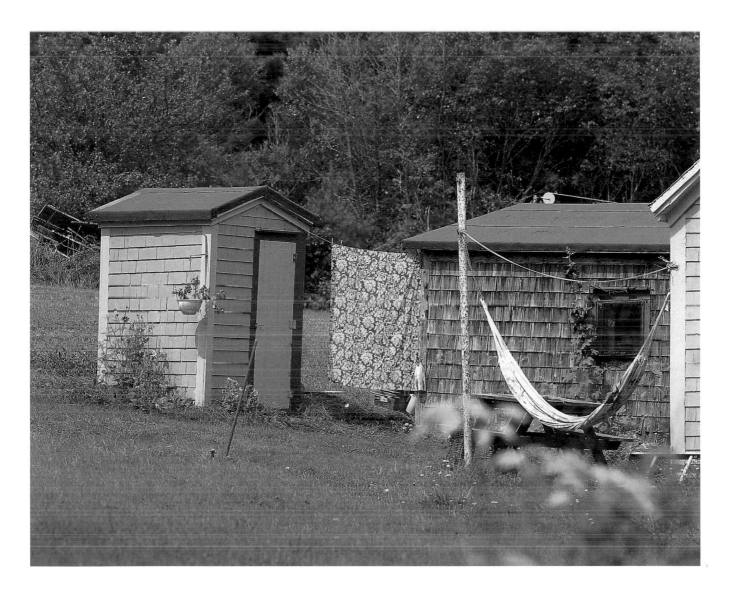

None in the hammock, one in the house…

(overleaf) Ah, the unmistakable smell of
clothes dried in country air.

33 ☾

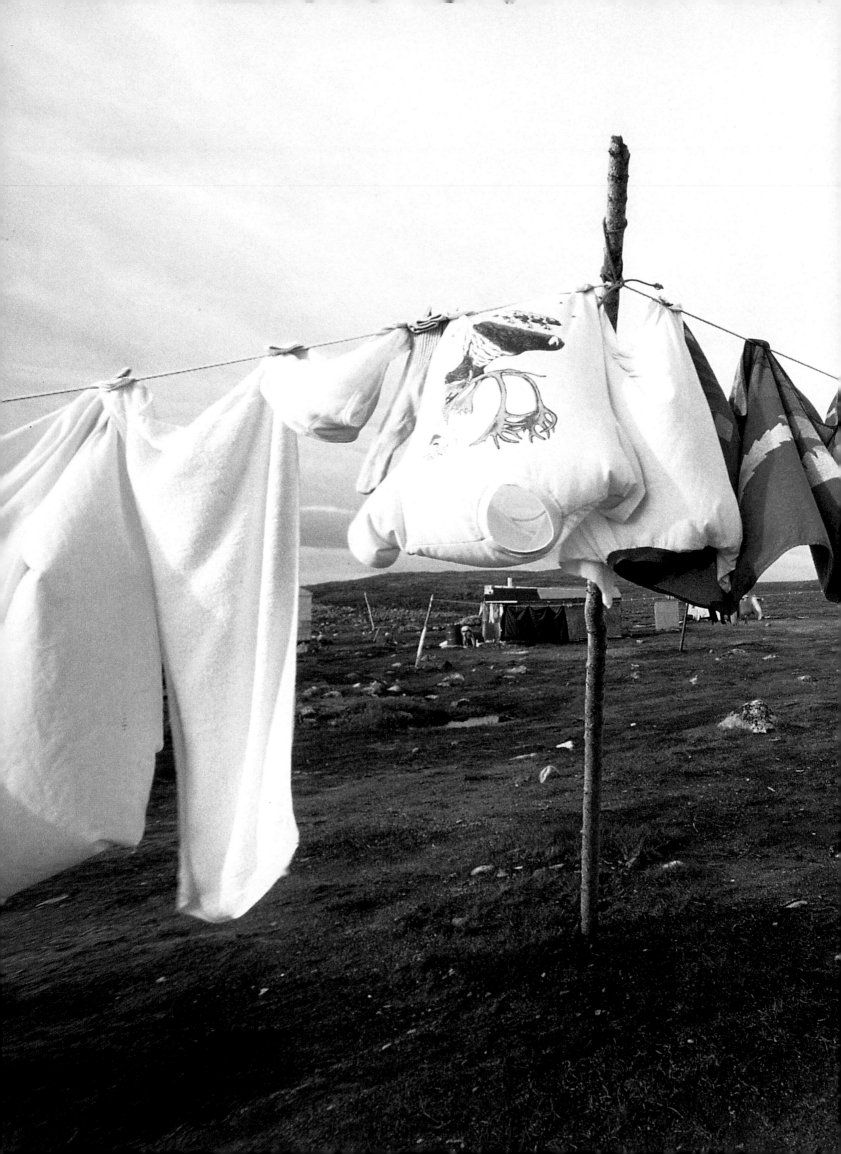

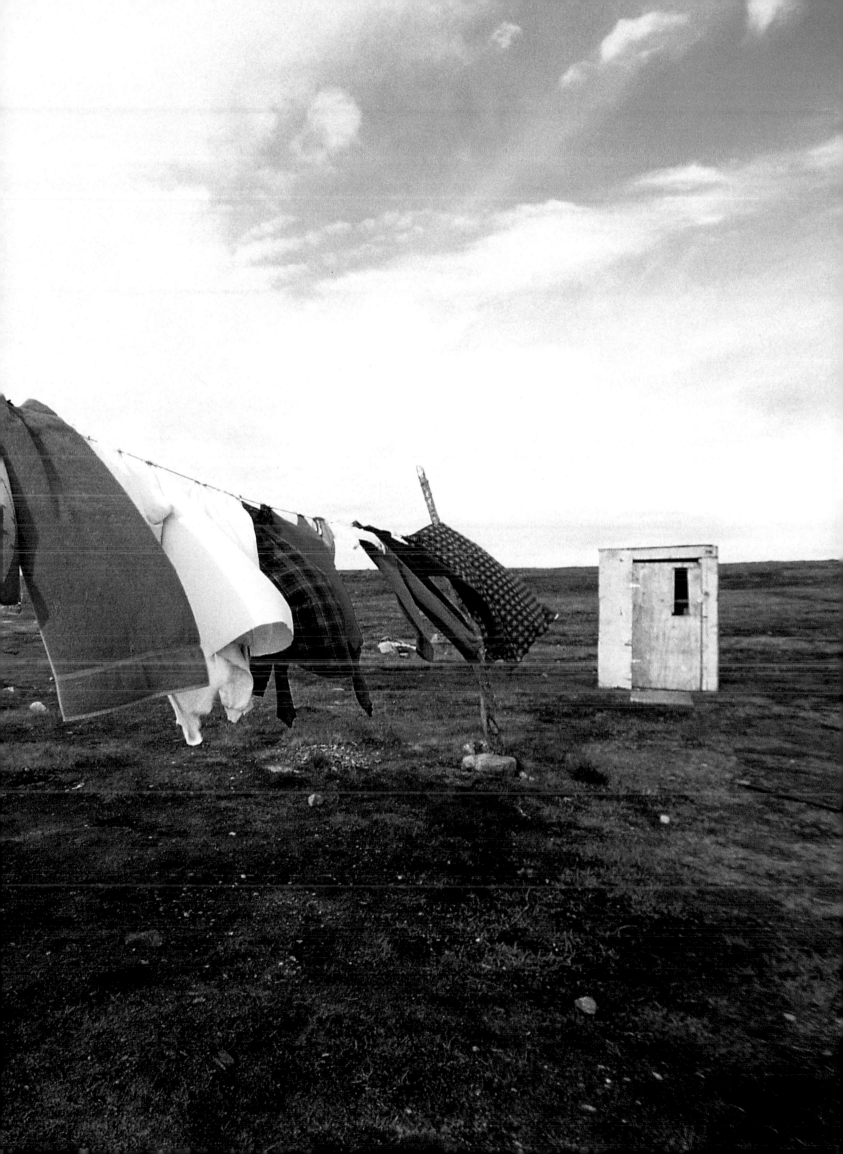

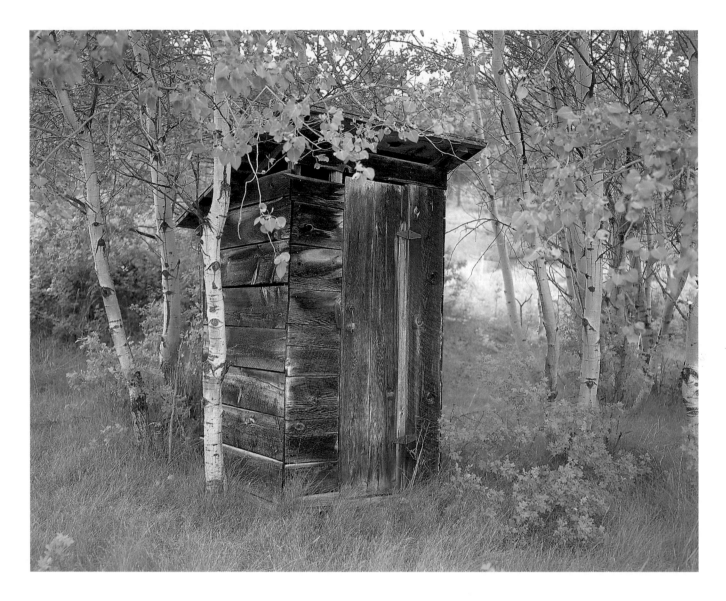

Behind every tree there is a lavitree.

A man's home is his castle. ▷

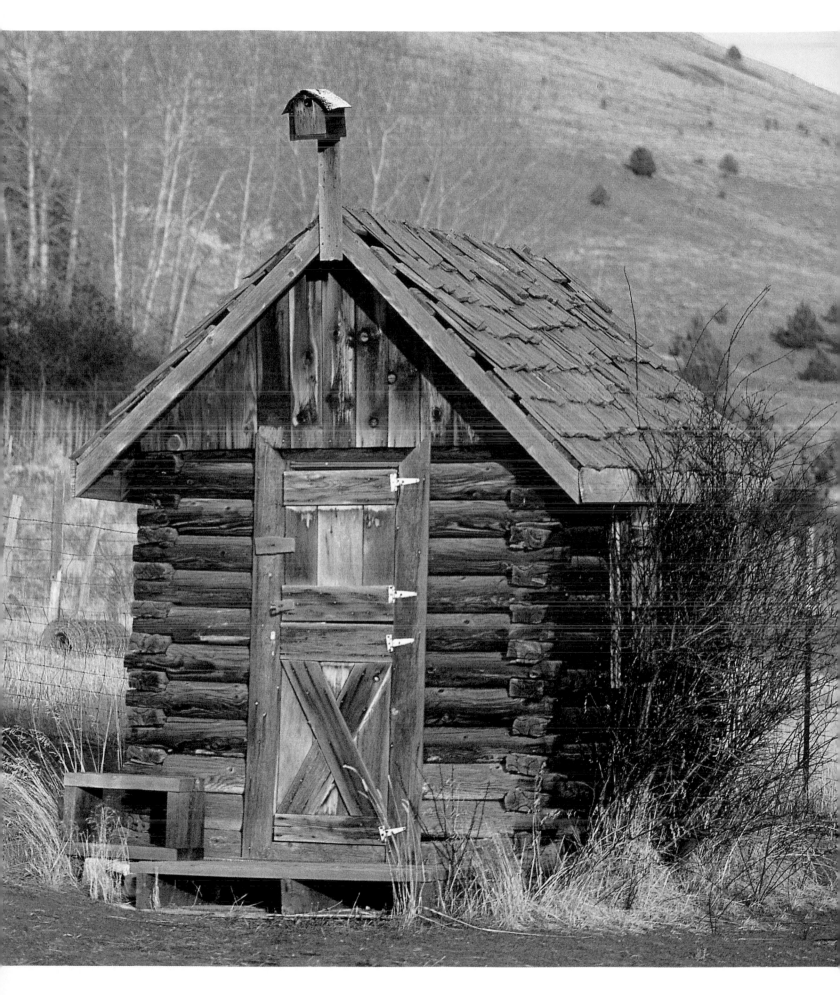

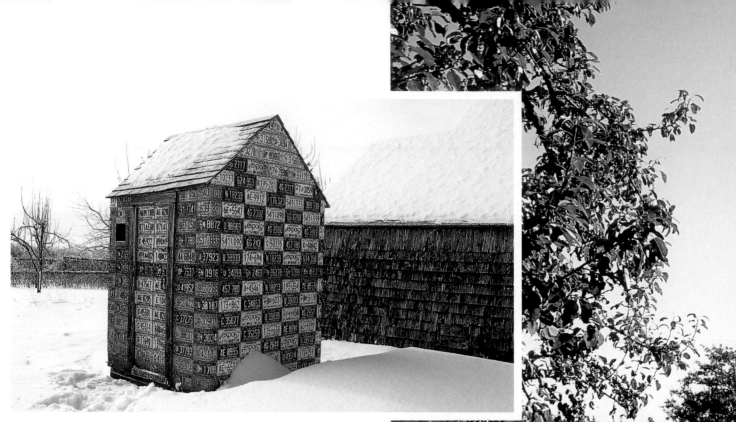

A license to
revisit,
release,
recycle
and
reuse.

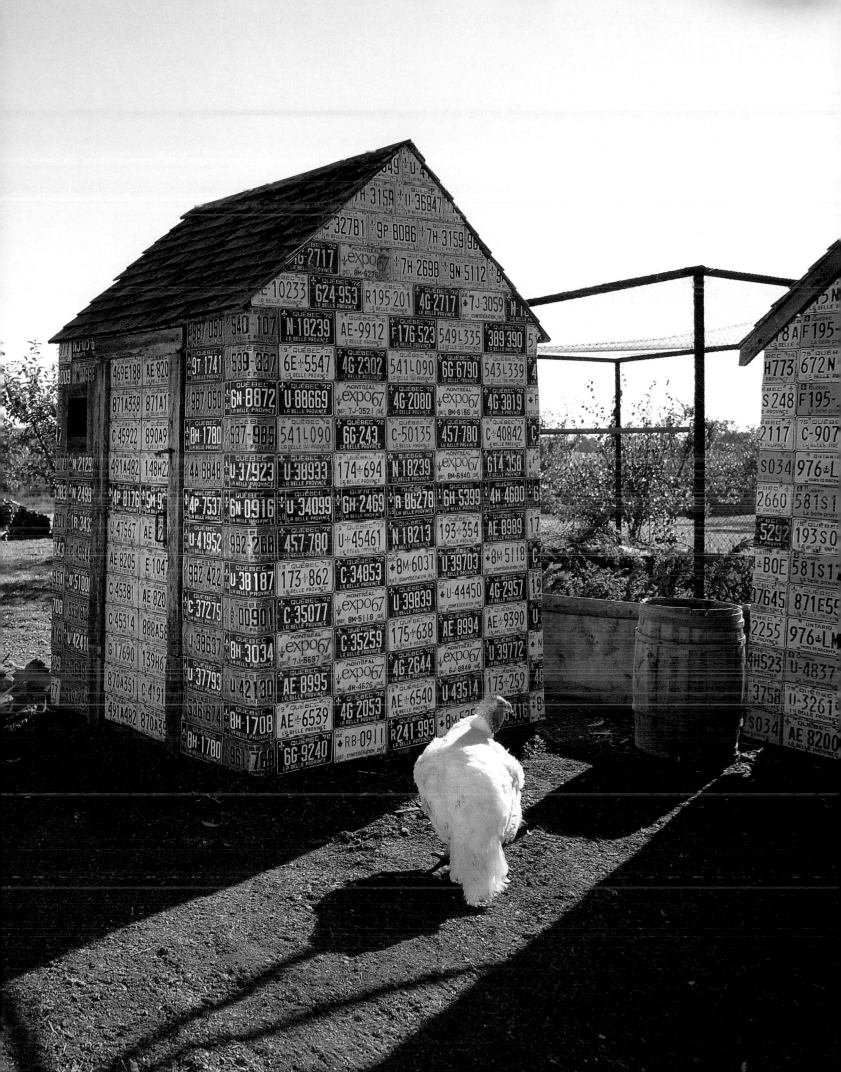

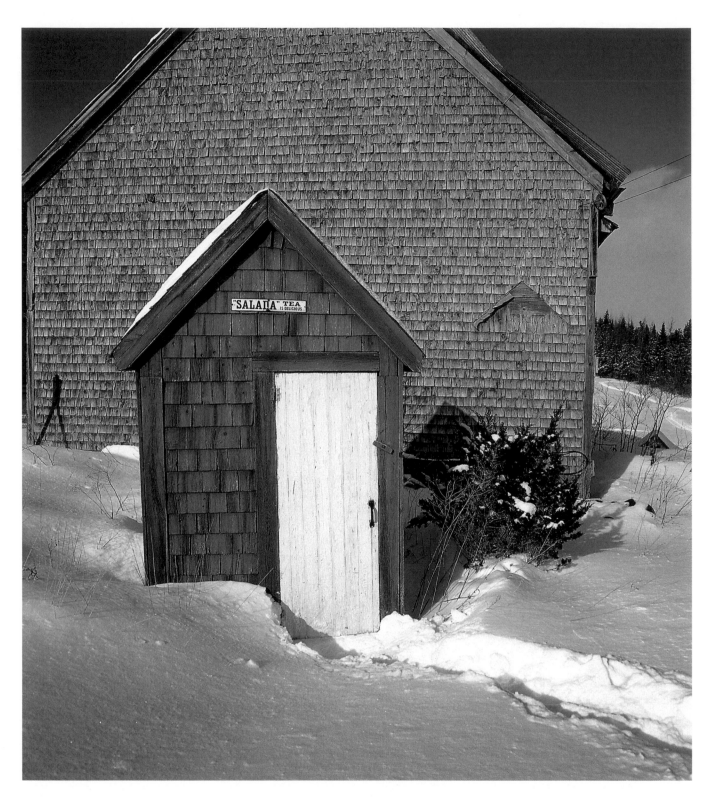

On the hole, afternoon tea is great.

Don't say you weren't warned. ▷

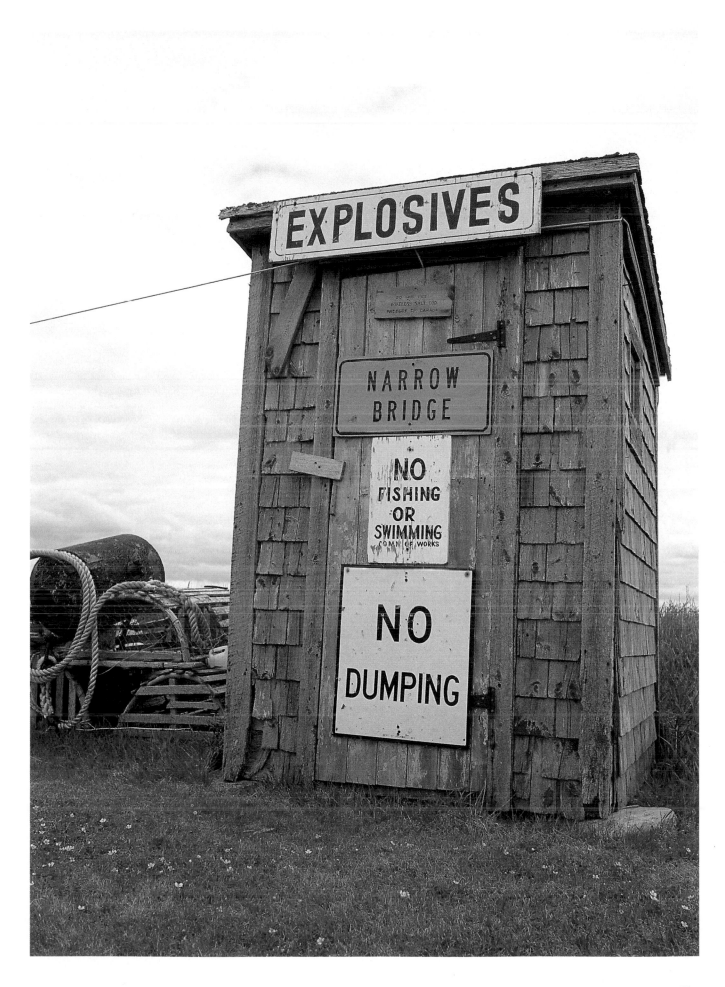

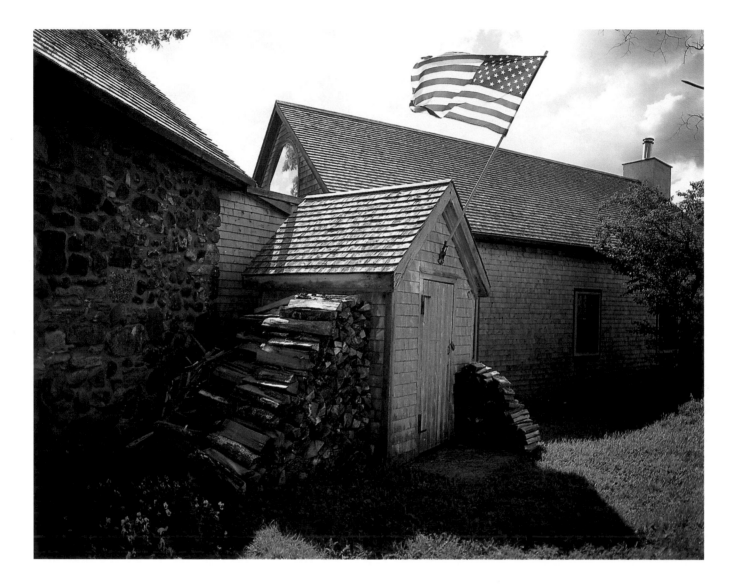

O say can you see from where you sit
that the Star-Spangled Banner still waves?

The flag at full mast means don't come in, ▷
my pants are at half-mast.

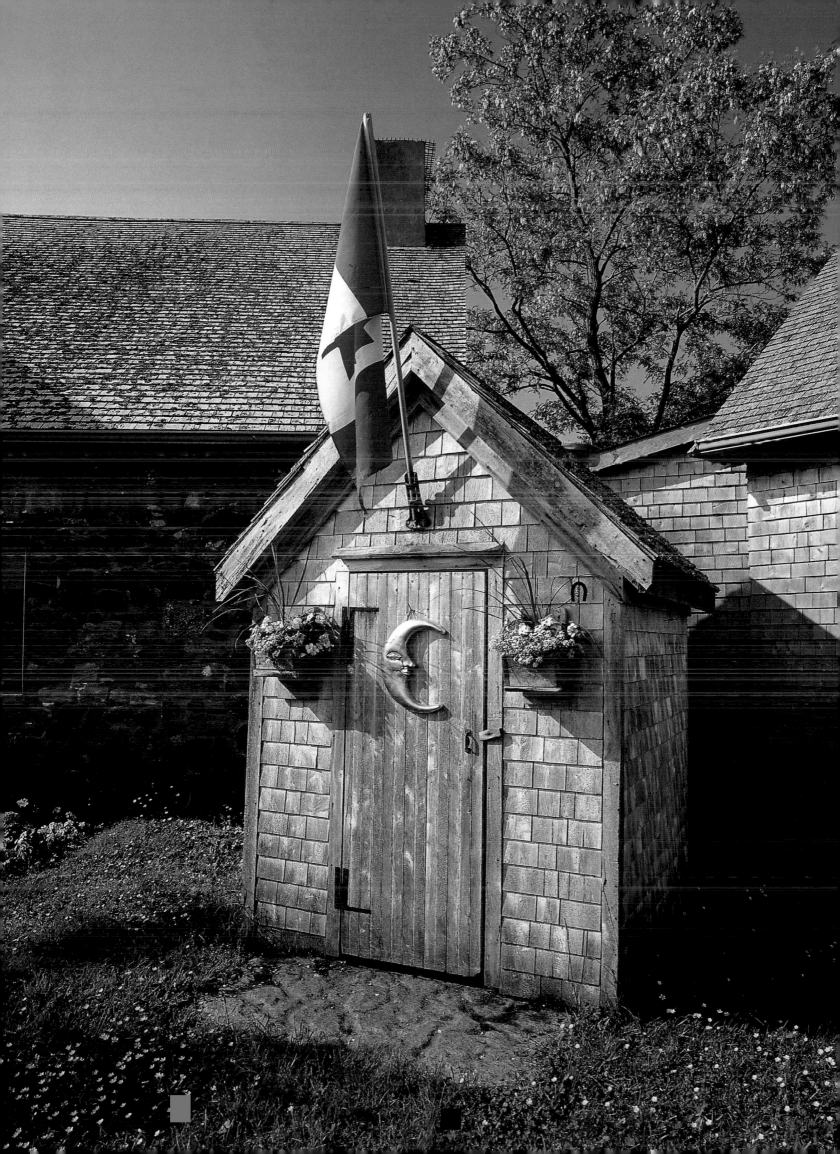

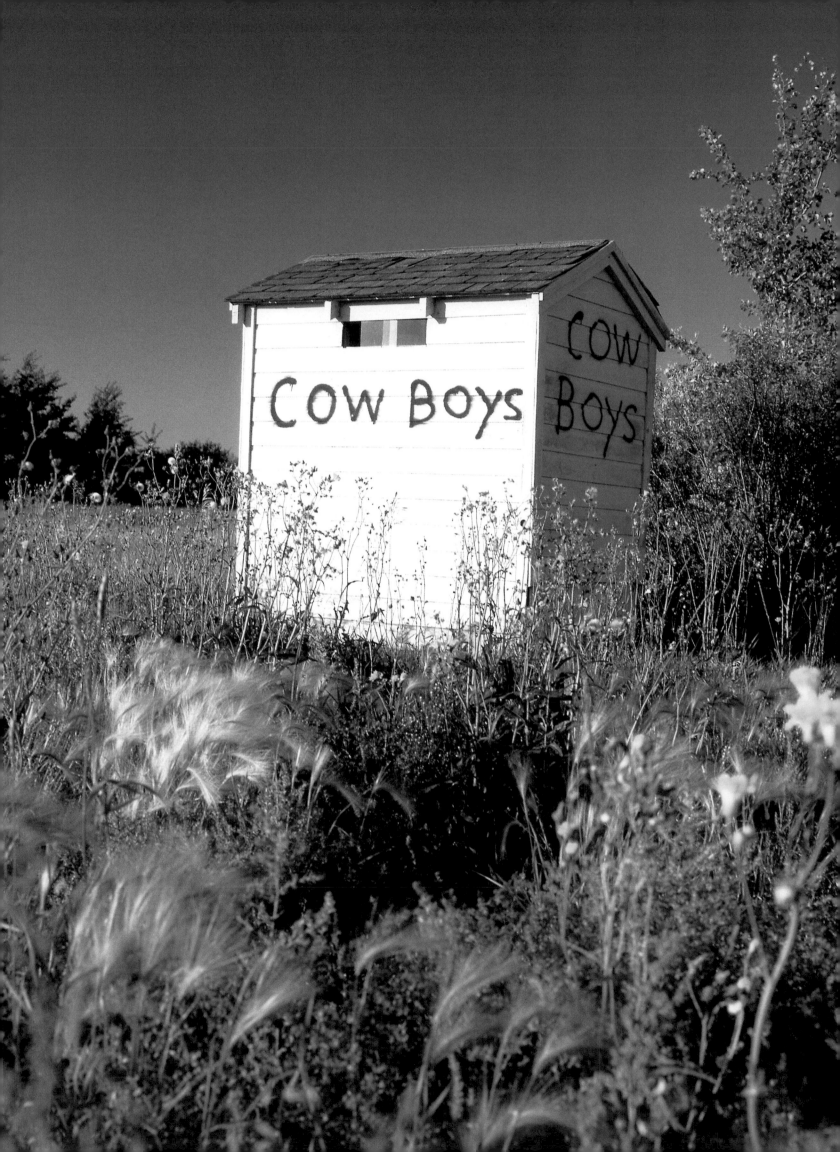

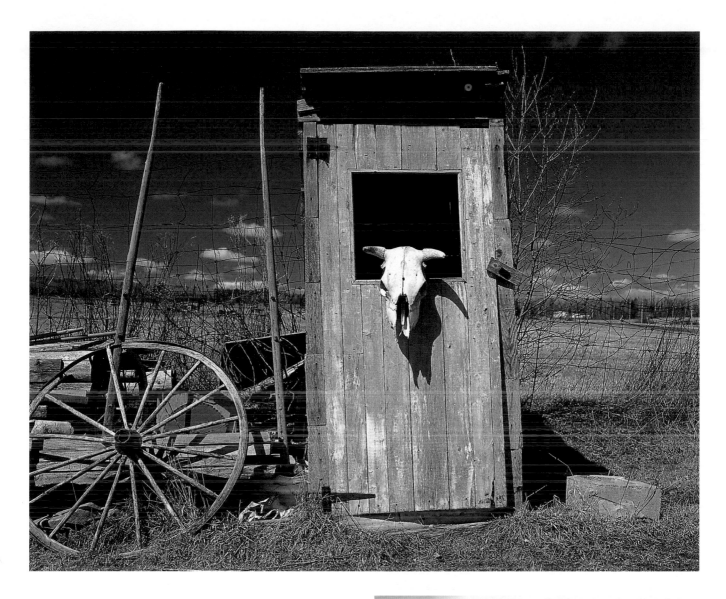

O give me a home where the
buffalo used to roam.

Man's best friend keeps the
old nag from moving in on you.

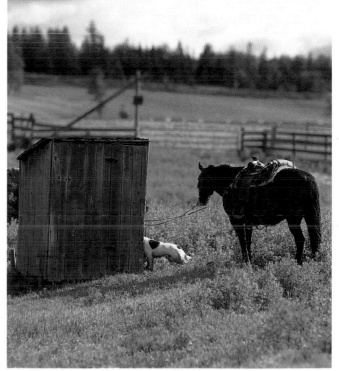

◁ Ladies, next pasture please.

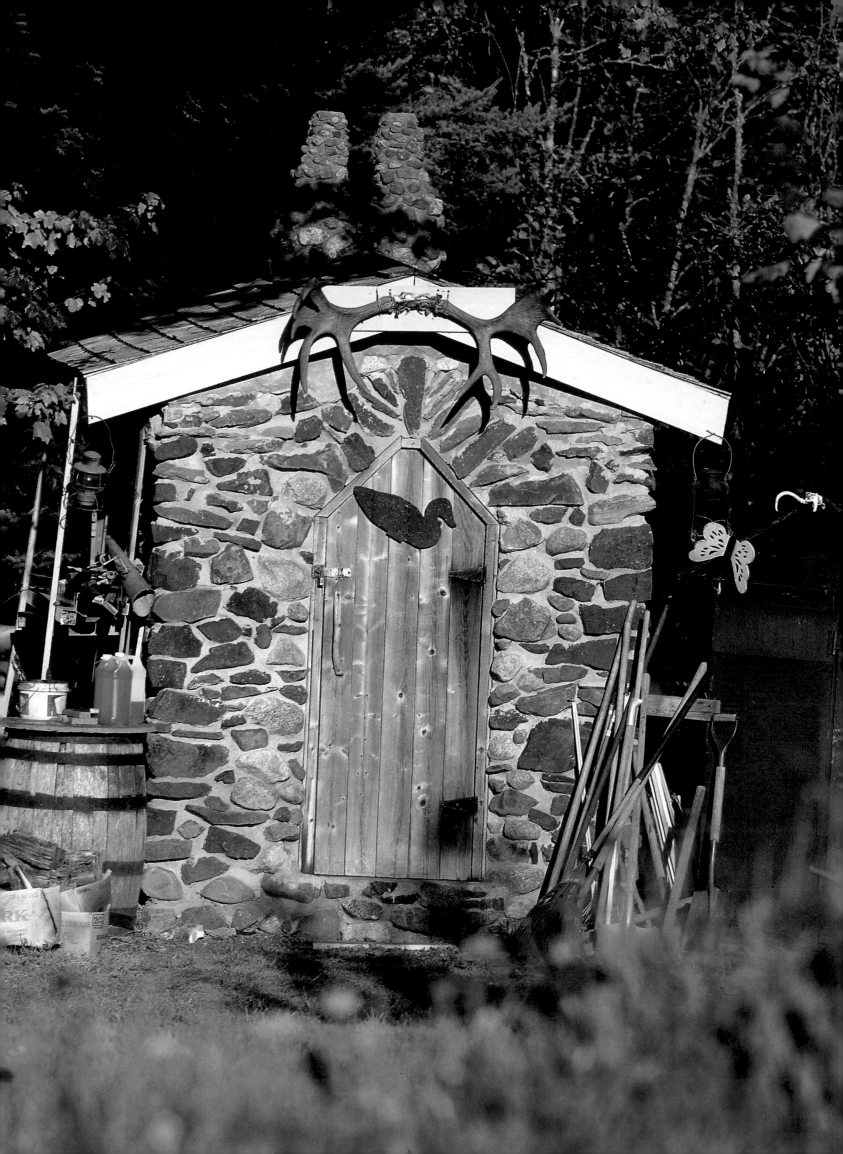

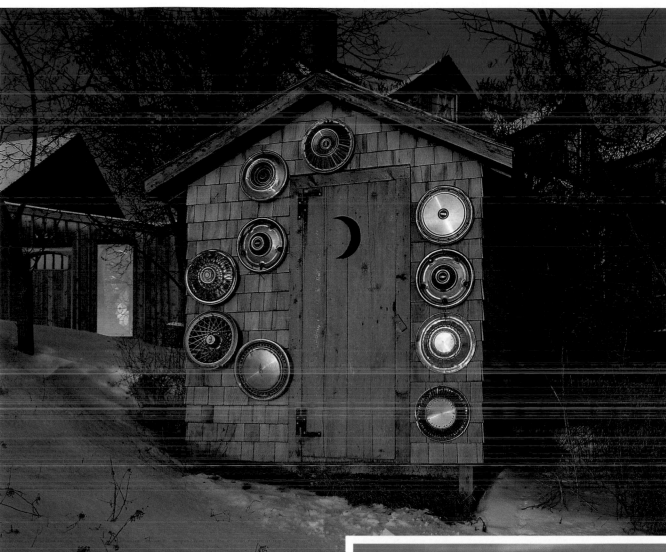

Where wuz you
when the wheels come off?

◁ During hunting season –
Stay low and duck!

Hoops, my dear!

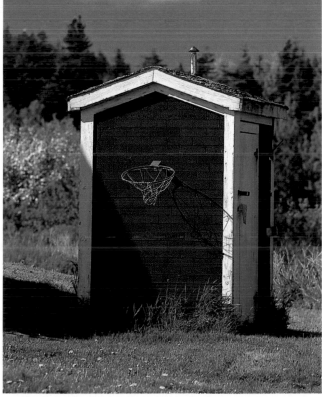

(overleaf) Who put a lien on my house?

47

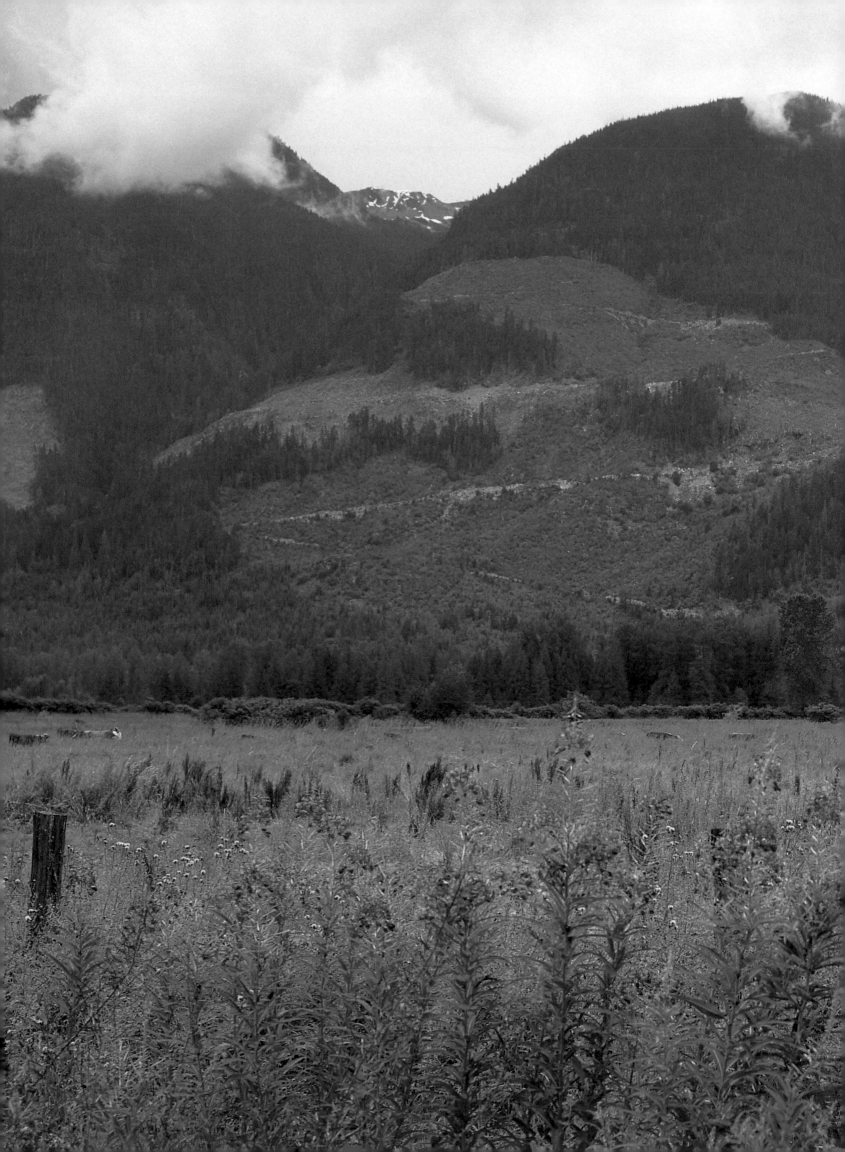

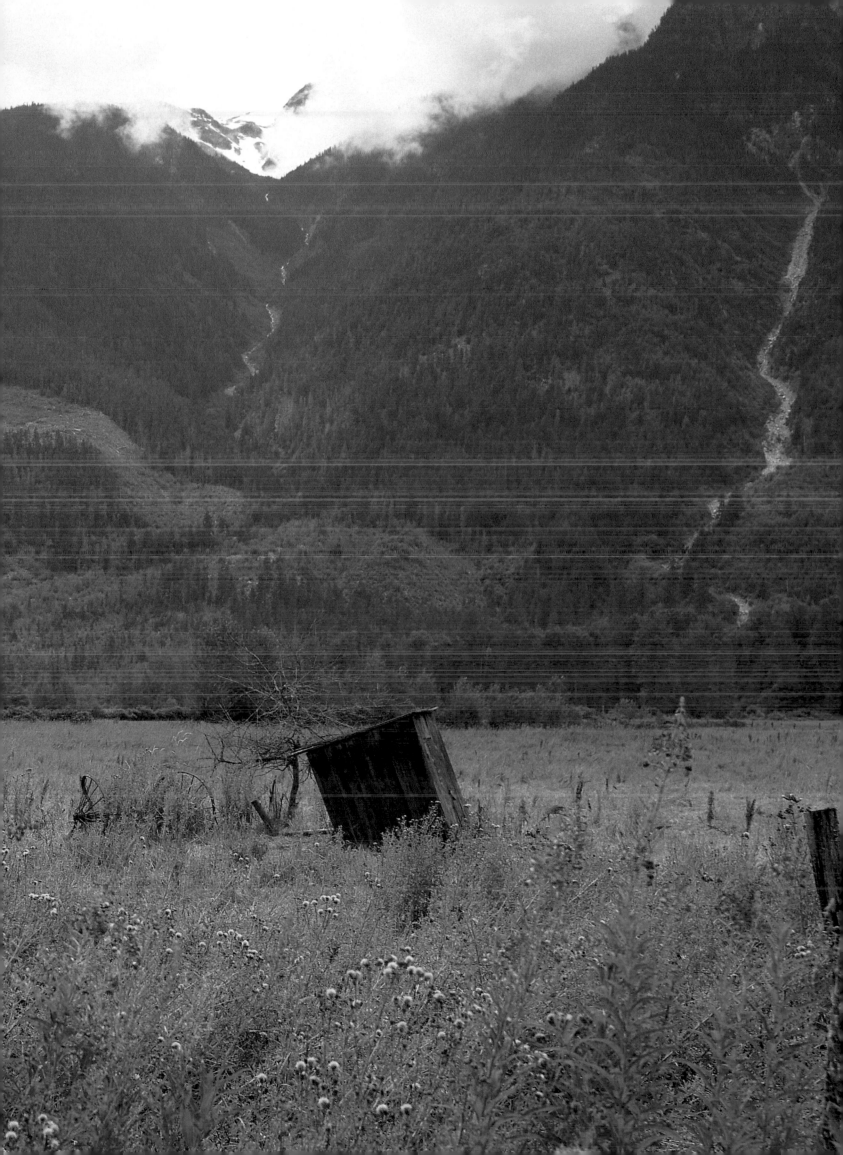

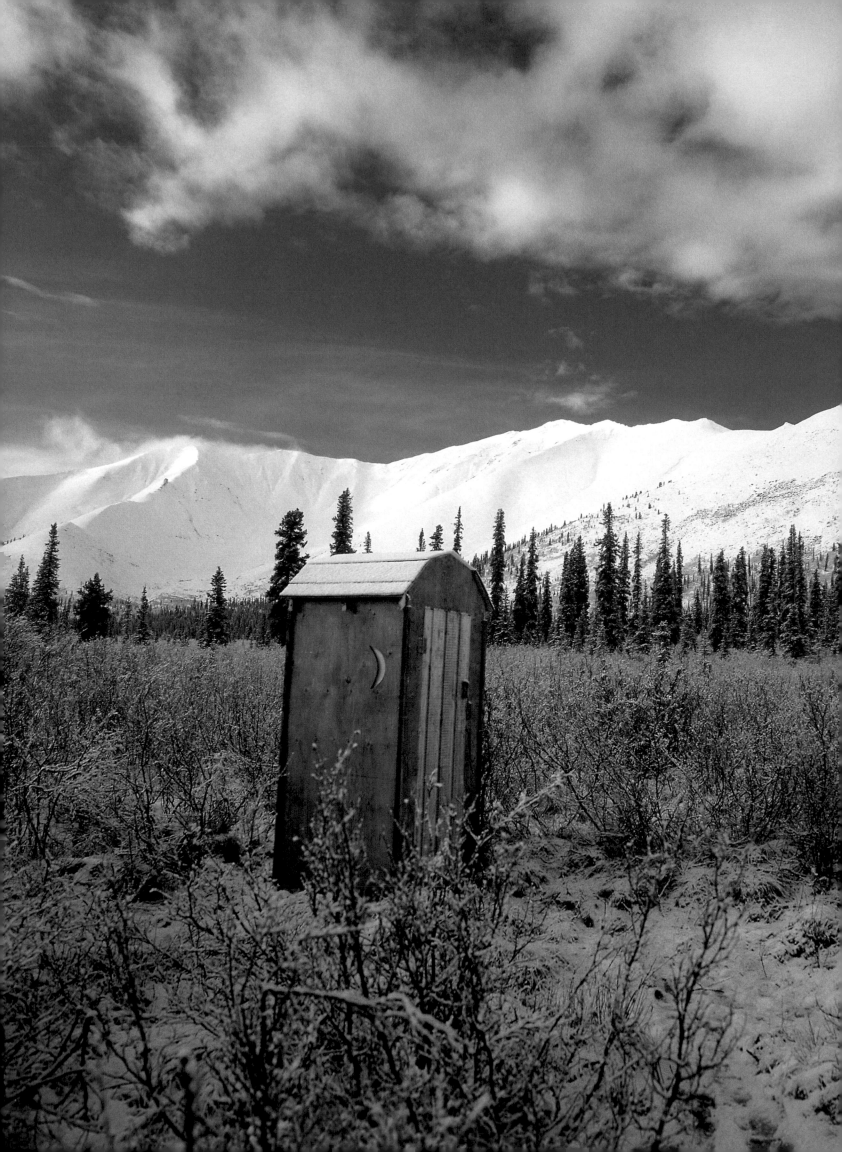

We all dwell in a house of one room
— the world — with the firmament
for its roof.
– *John Muir*

The scenery is majestic, but right now it
is the little house I'm most glad to see.

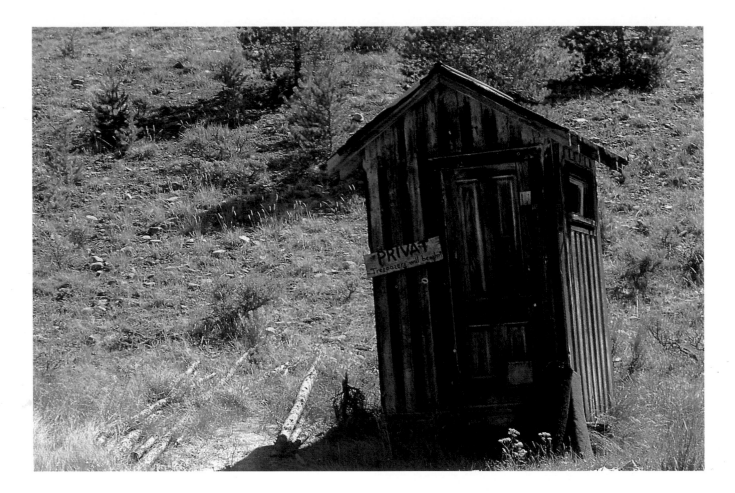

Use at your own risk.

Carefully positioned to preserve the privacy and
dignity of all comers with a coat rack by the door. ▷

(*overleaf*) Far away in the mountains
a shepherd hears their thundering.
— *Homer*

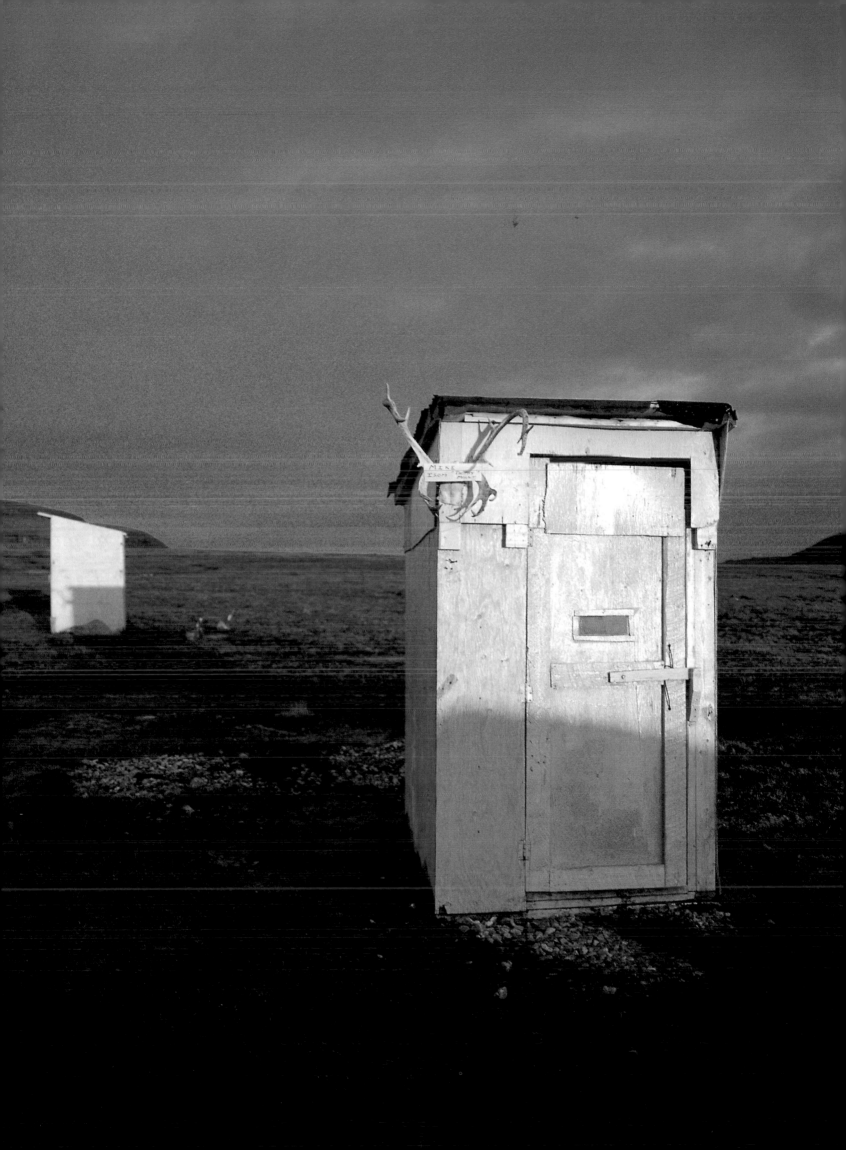

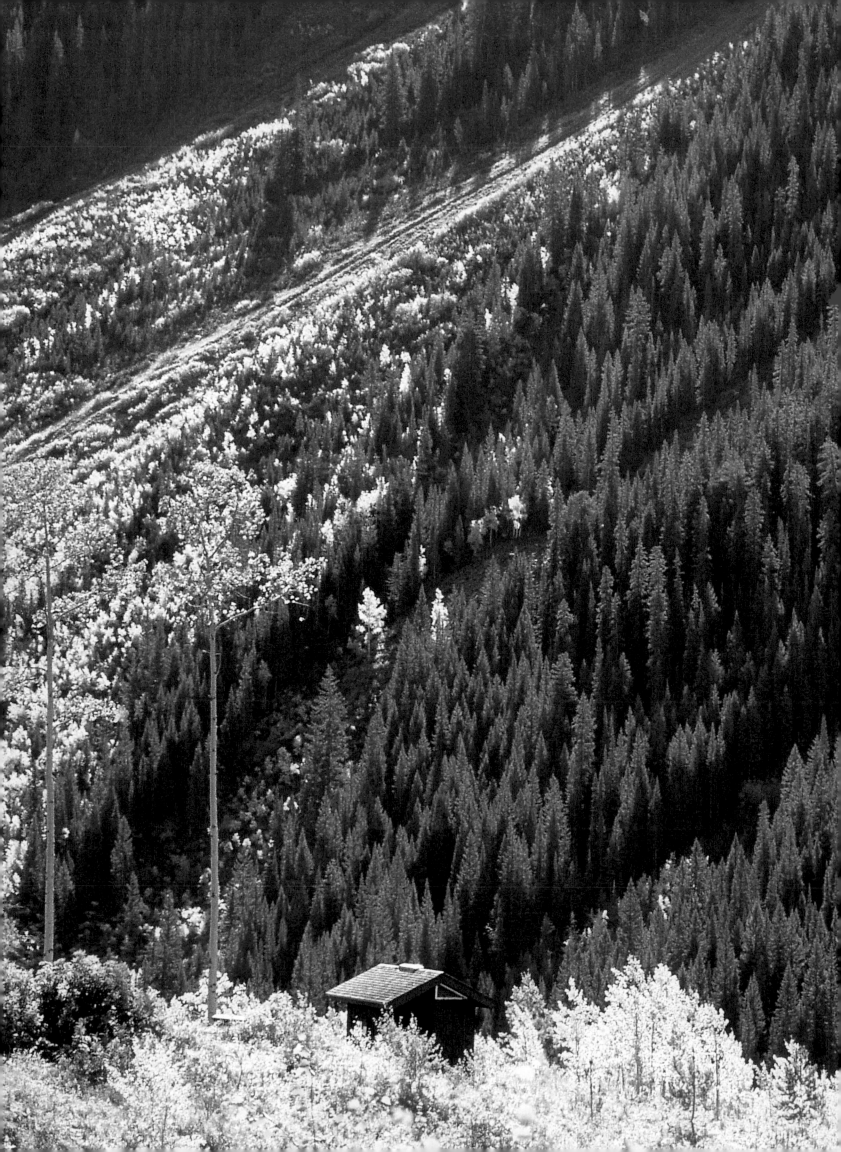

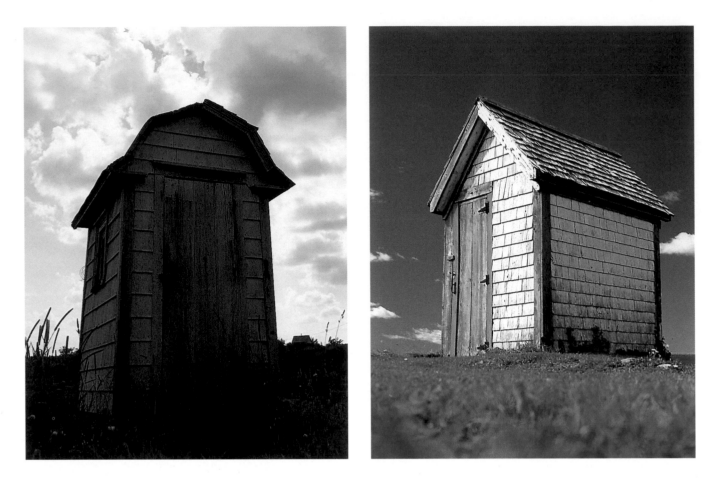

You find us in all shapes and sizes everywhere you go!

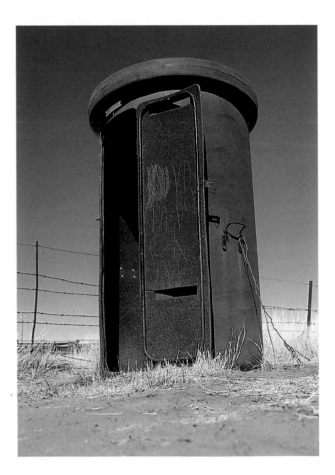

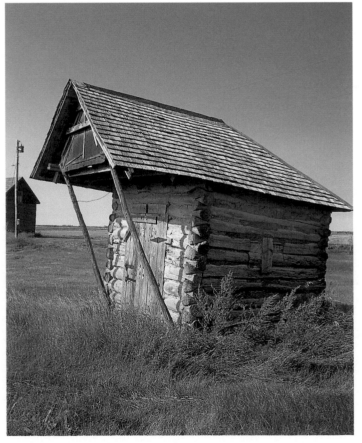

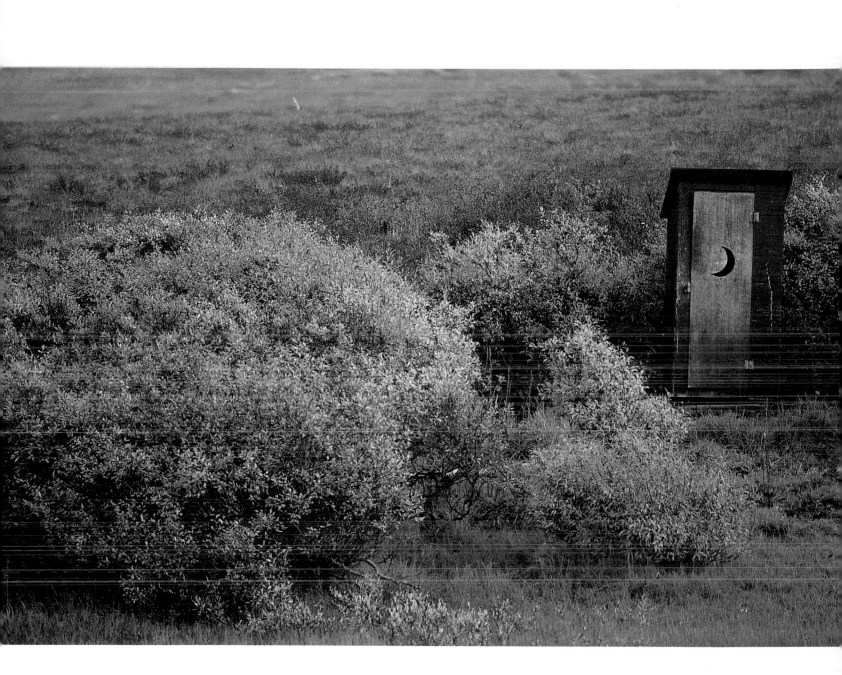

The crooked smile on the door bids you welcome.

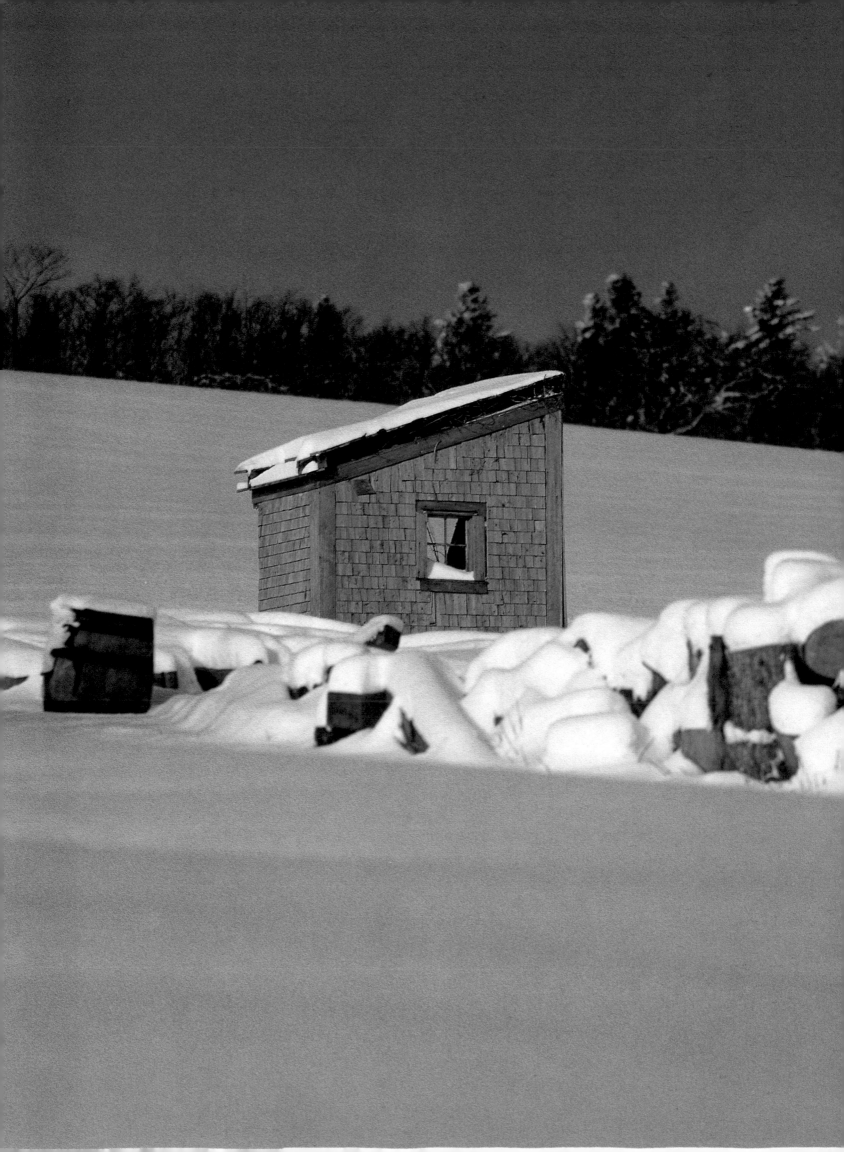

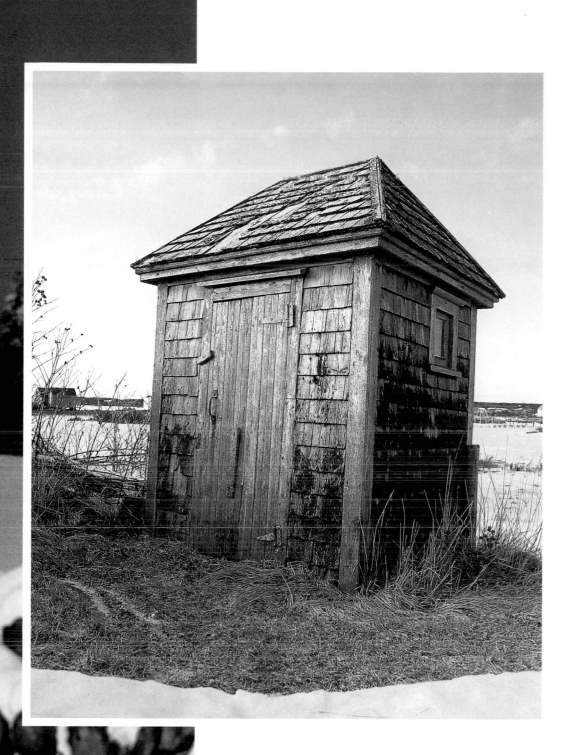

All nature seems at work — and winter, slumbering in the open air, wears on his smiling face the dream of spring!
Samuel Taylor Coleridge

59

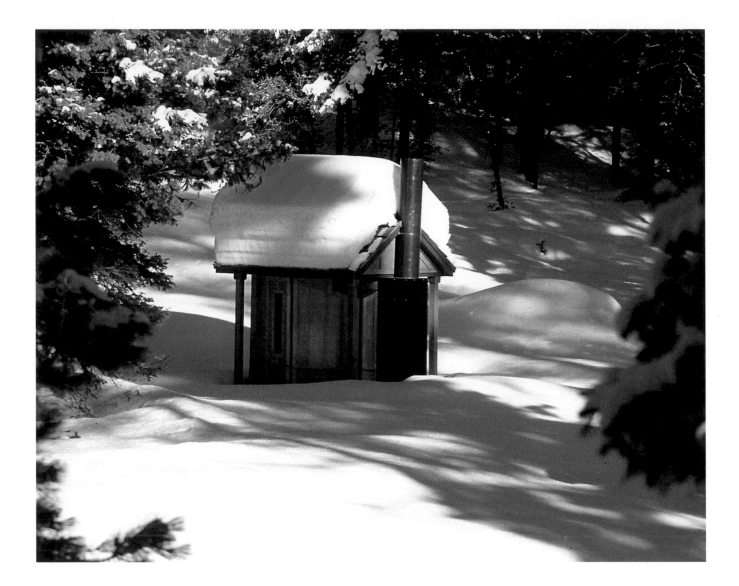

If we knew you were coming we'd have put the fire on.

Shut, shut the door good John! ▷
— *Alexander Pope*

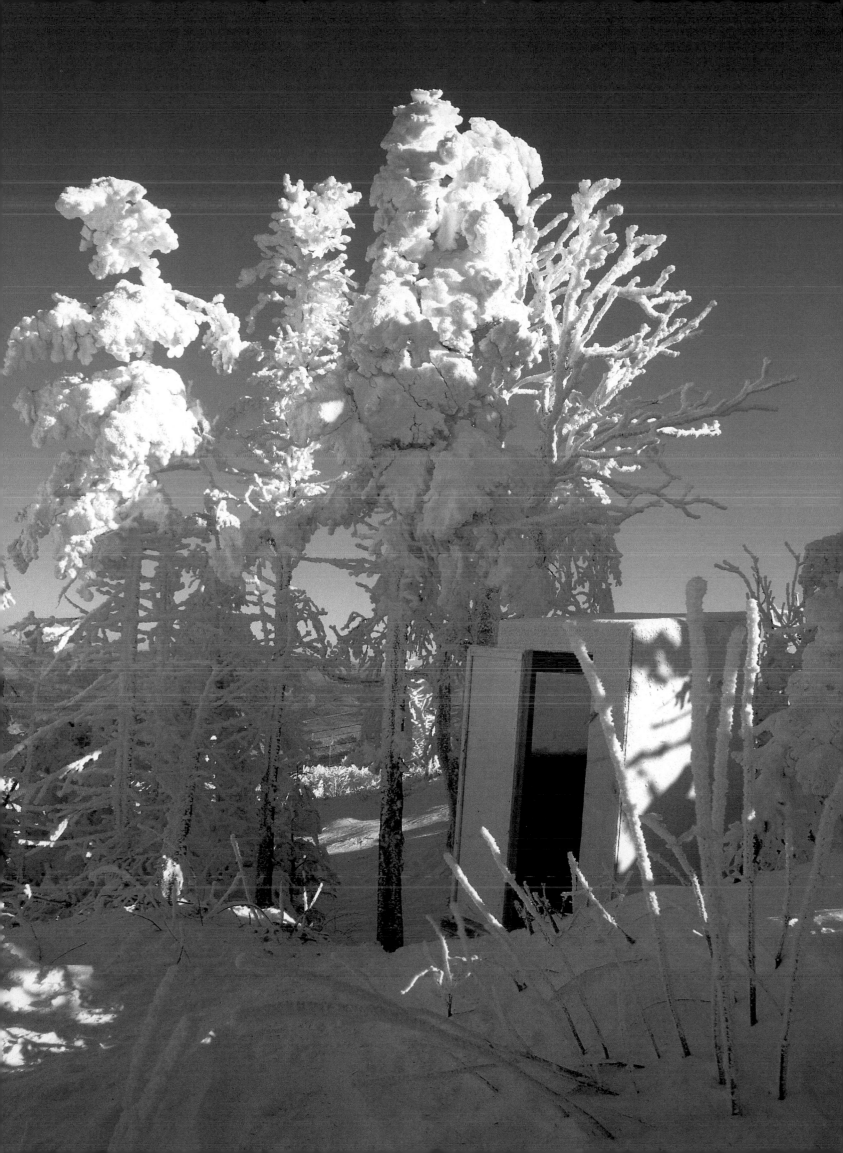

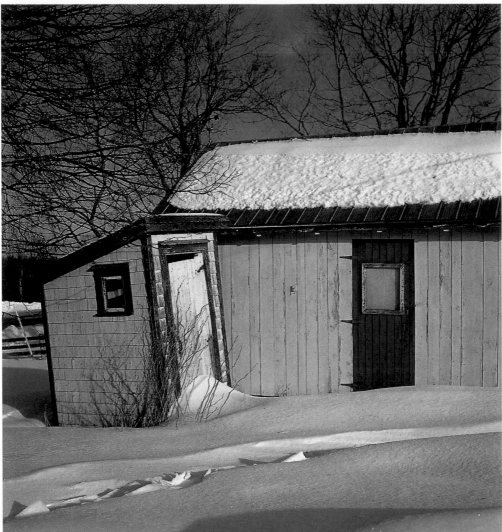

Driftin' and dreamin'.

How do you spell relief? ▷
S H O V E L.

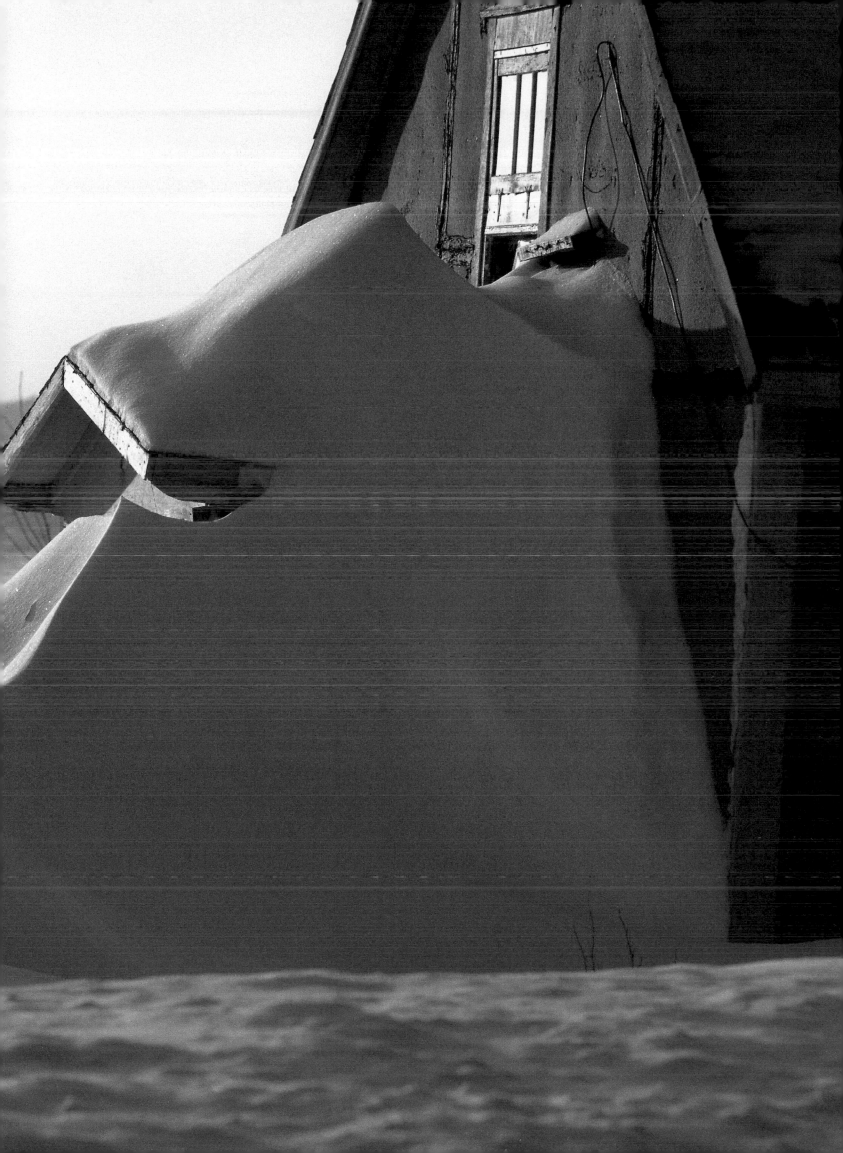

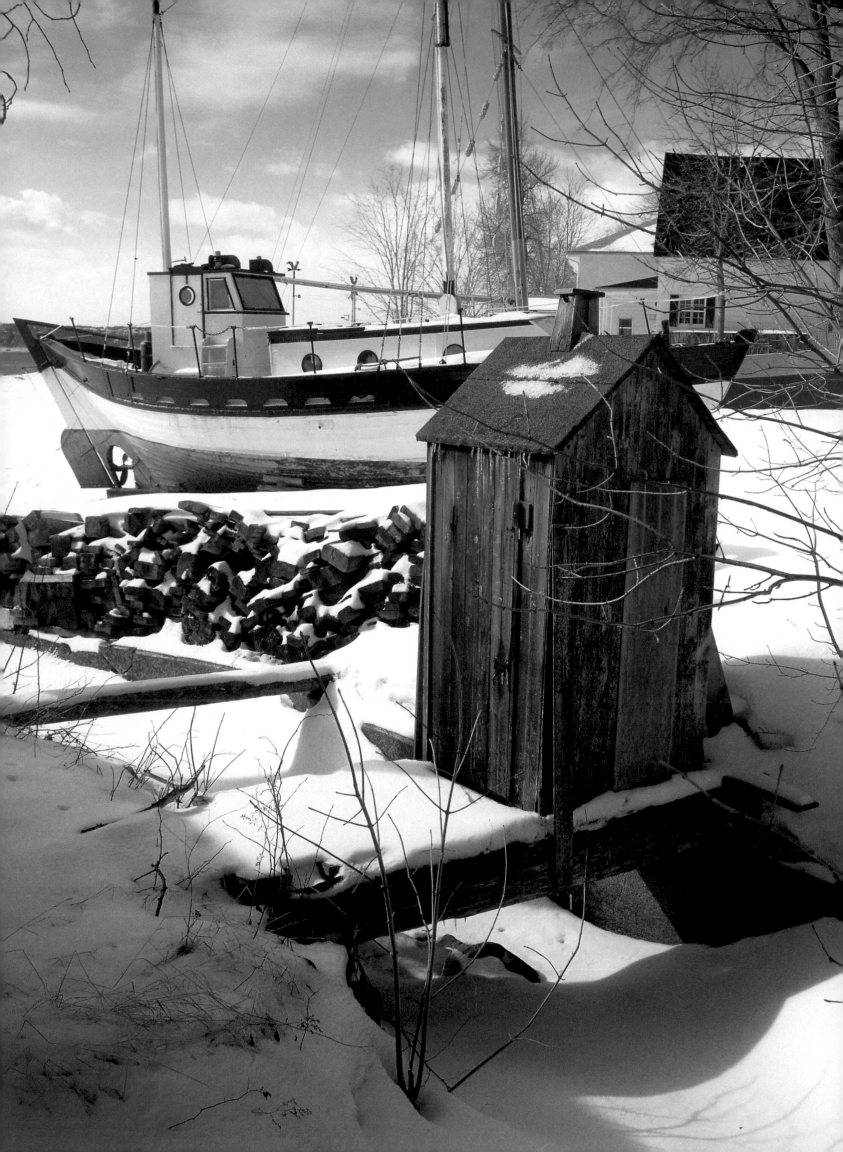

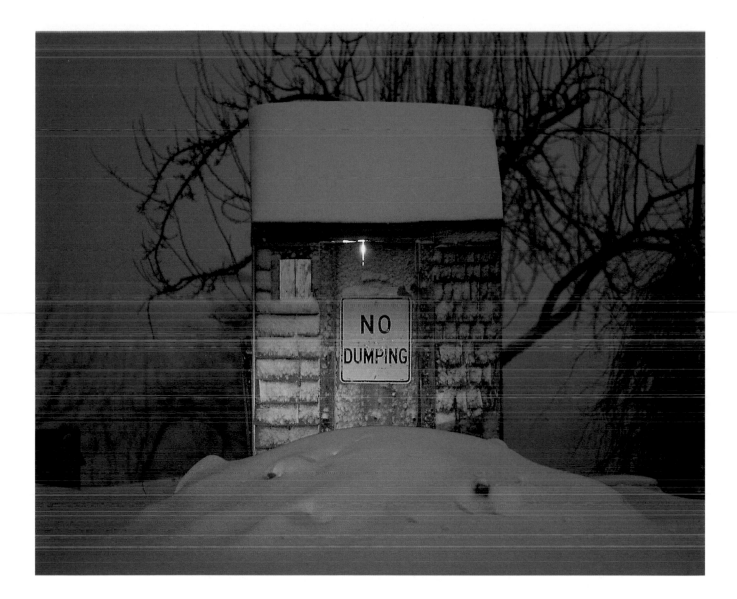

When ya gotta go, ya gotta go!

◁ A very ancient and fish-like smell.
— *William Shakespeare*

(overleaf)
Make tracks for the big house, my deers.

65 ☽

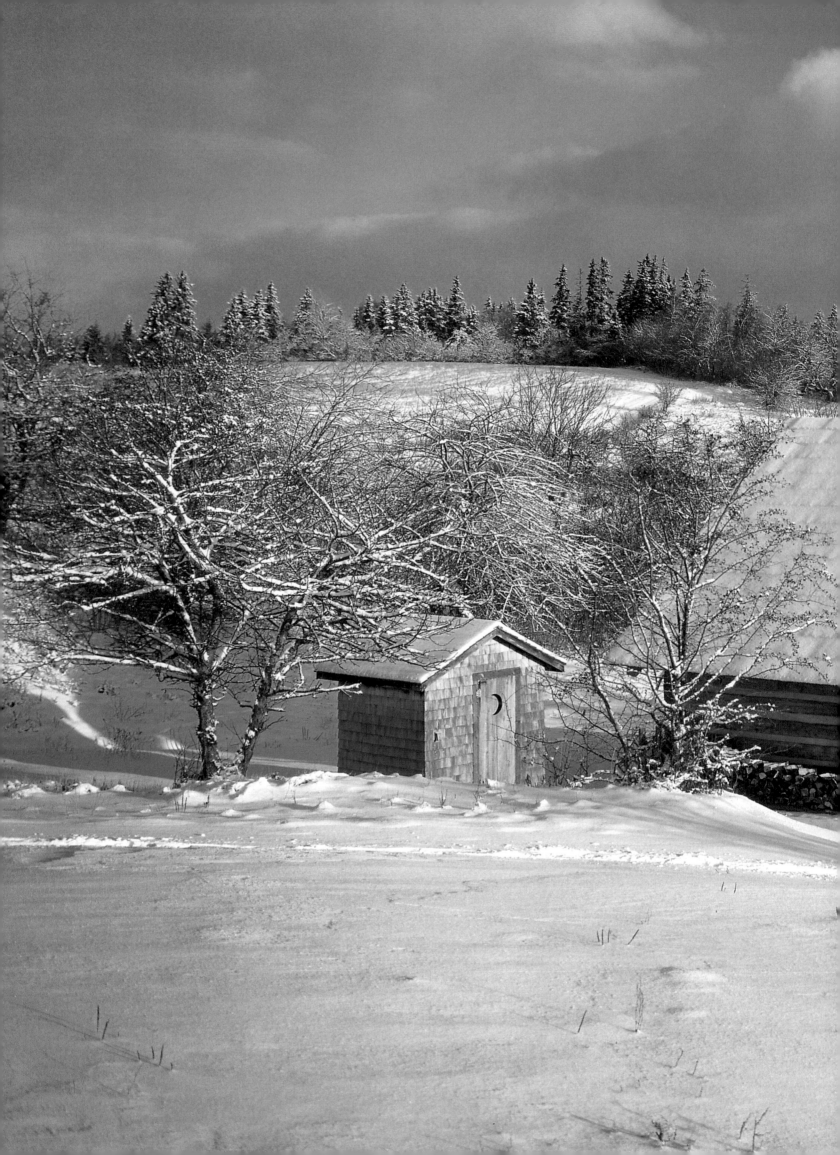

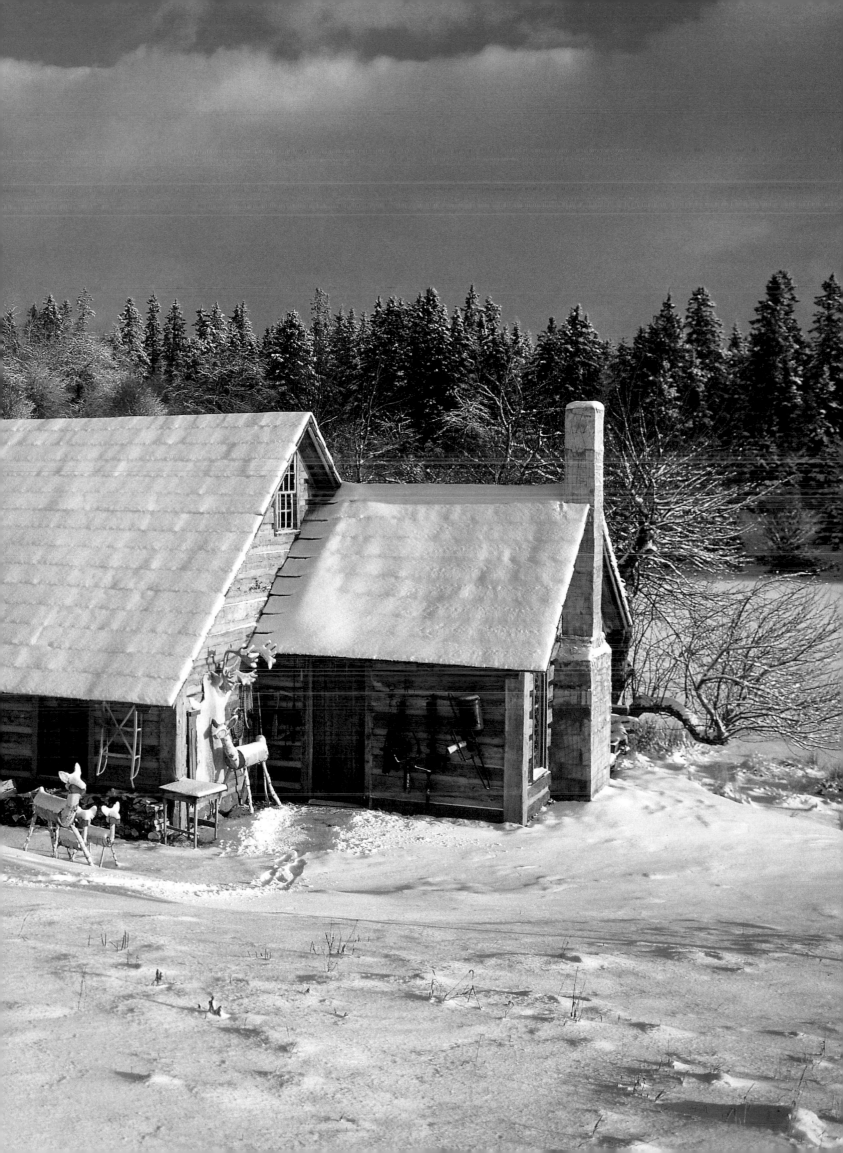

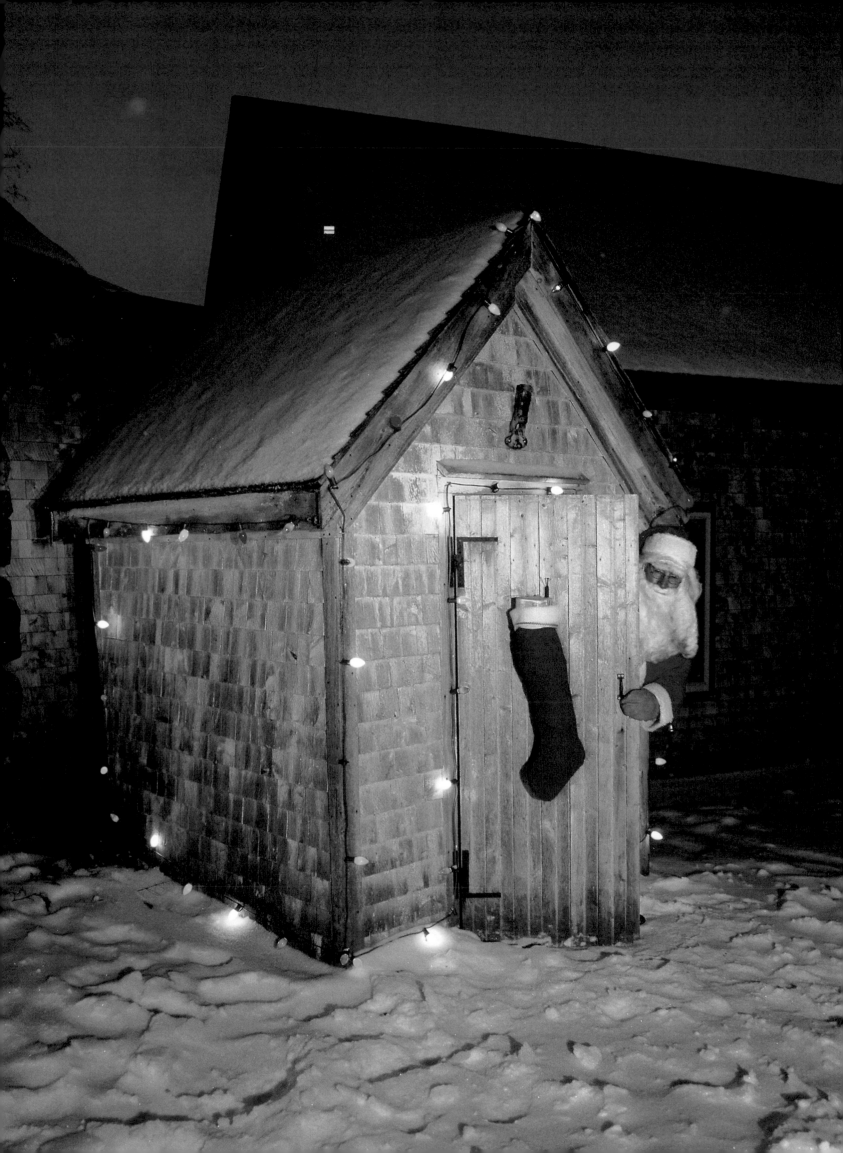

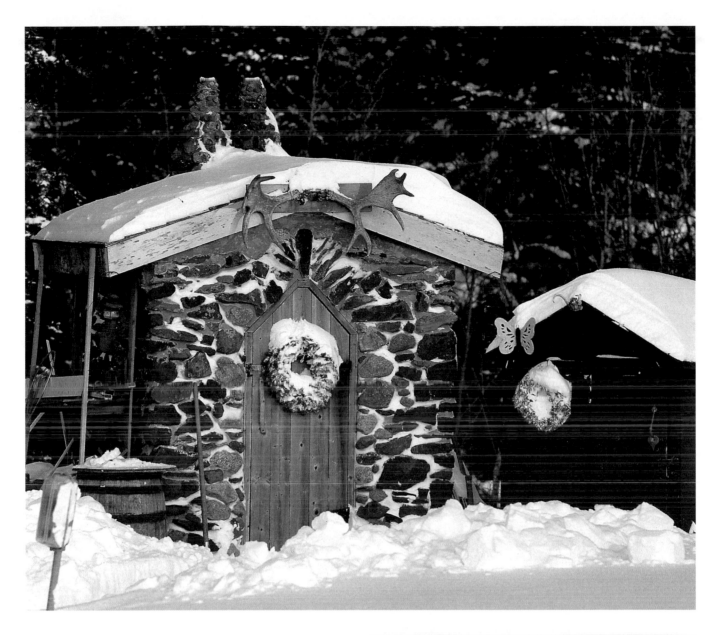

It may be wreathed in snow, but it's colder than Billy Be-Dam inside too!

It's nice to get lit up at Christmas.

◁ 'Twas the night before Christmas, and outside the house, Santa Claus got hung up with a stocking while waiting on my spouse.

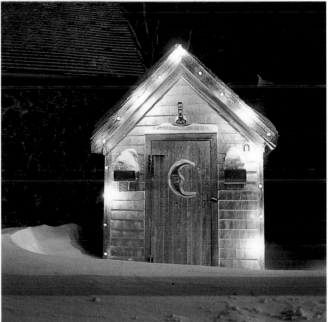

(*overleaf*) A home away from home.

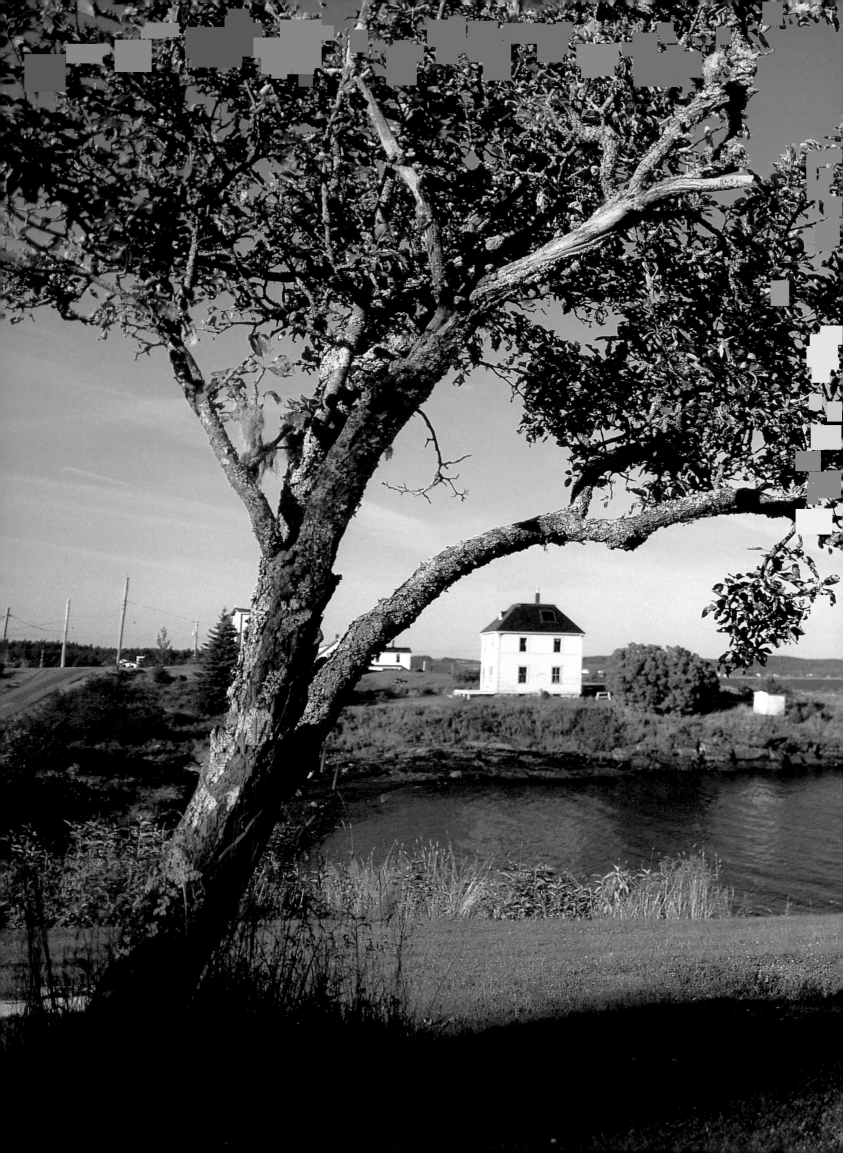

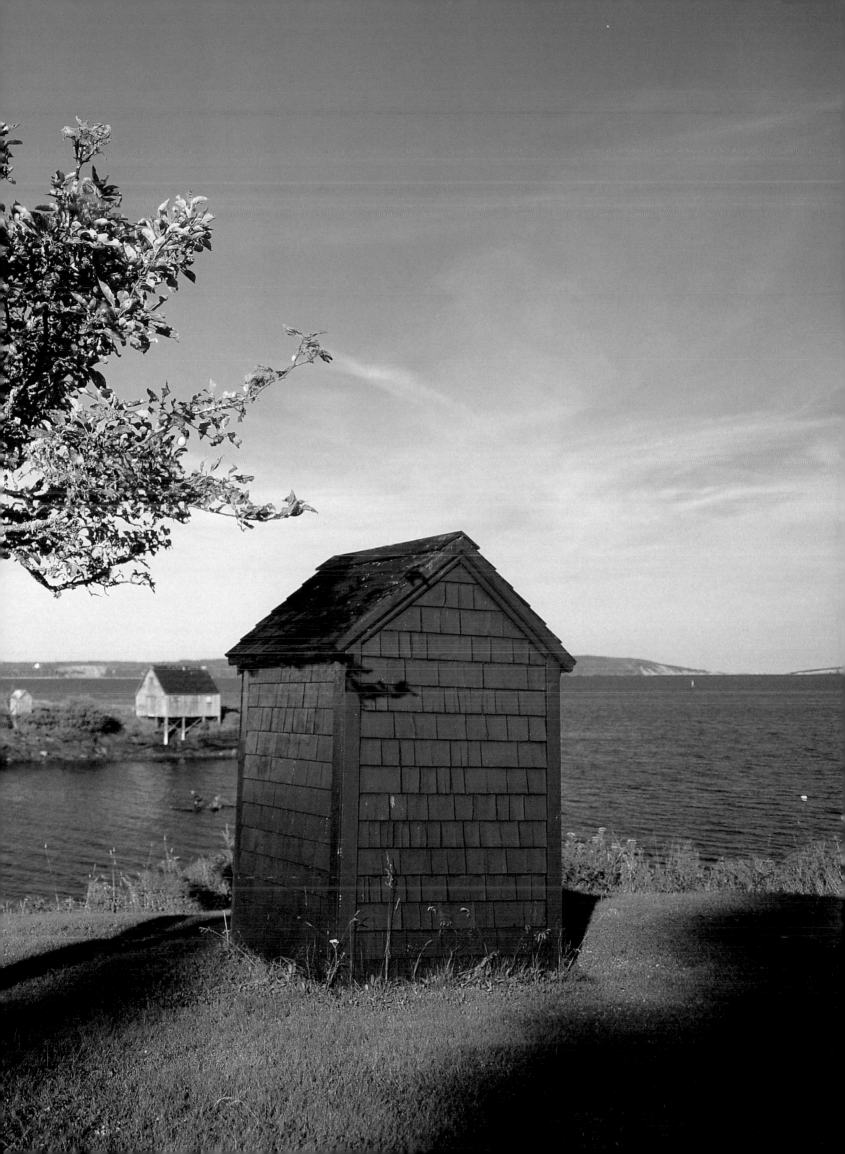

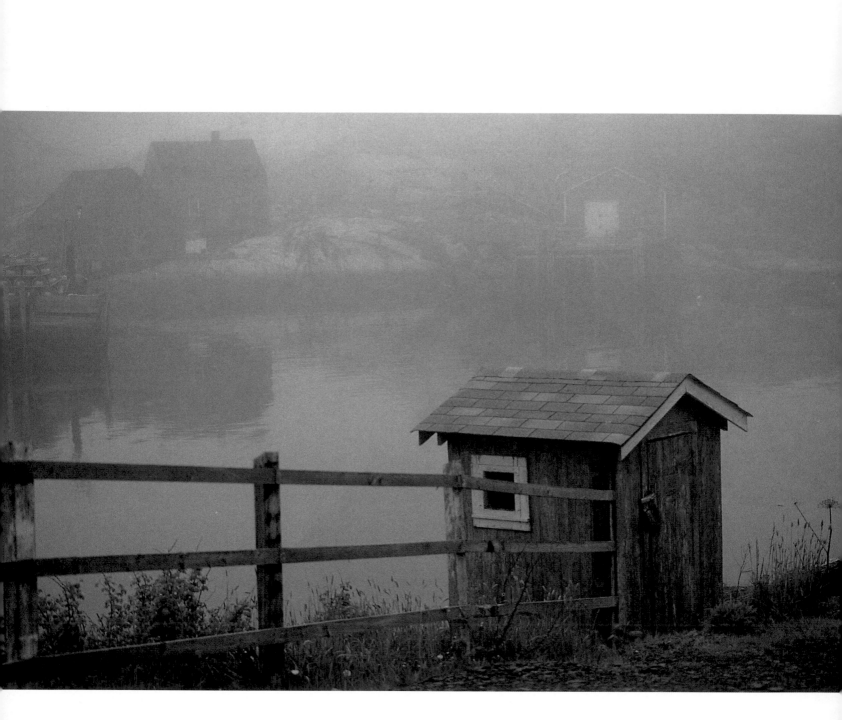

You can't miss it. If the fog becomes too thick just follow the fence.

The bull works against ▷
the invasion of your privacy.

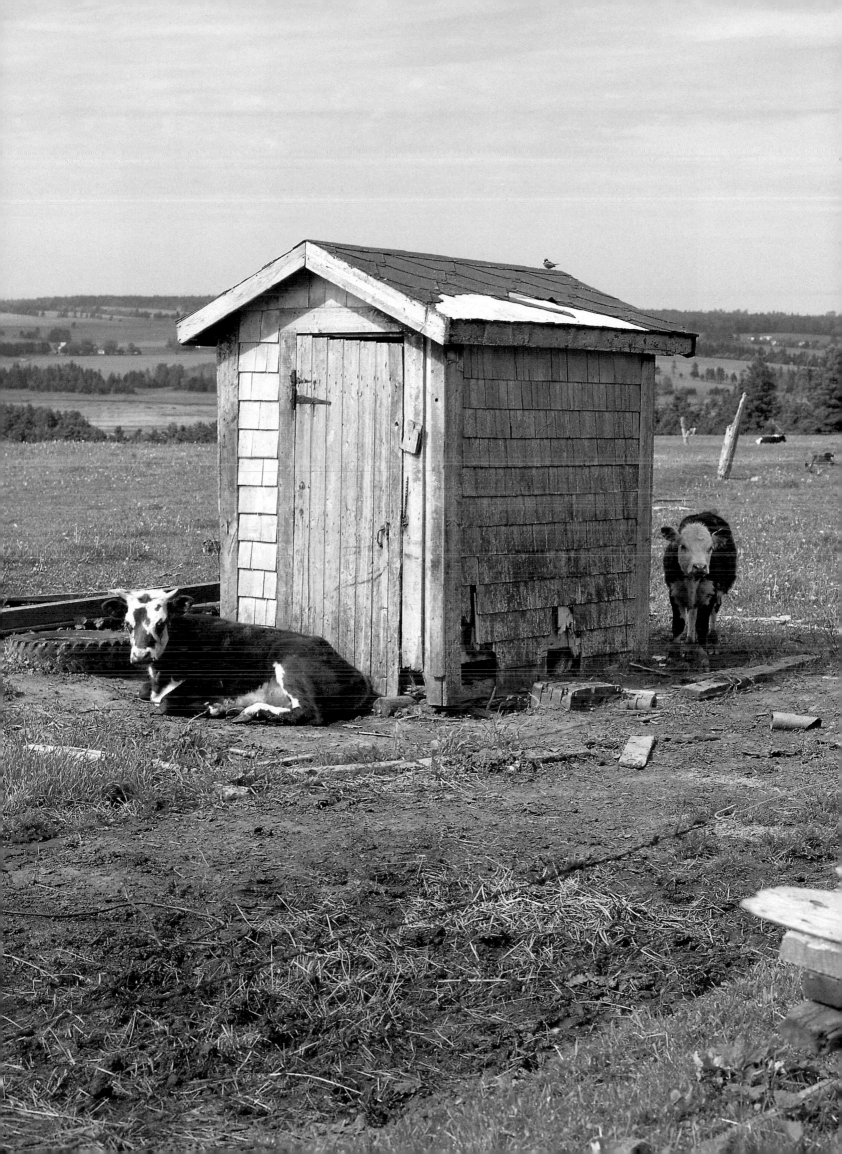

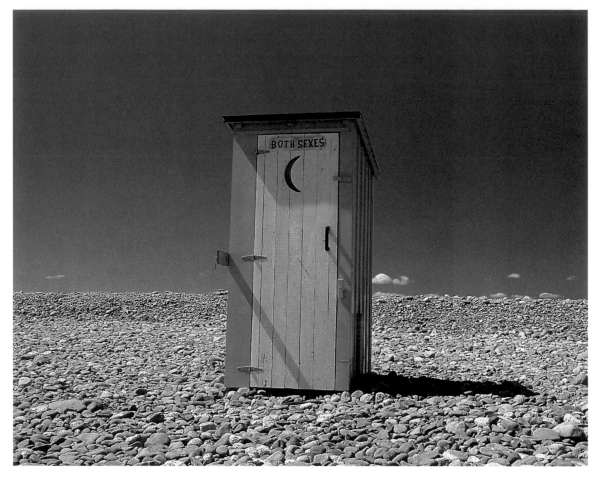

But only one at a time!

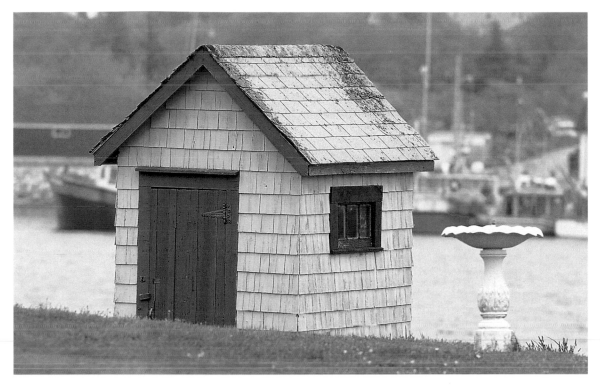

With a hand basin too!

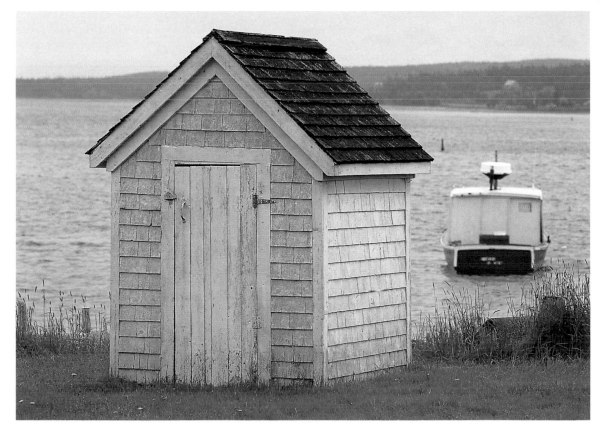

Use your head before heading out to sea.

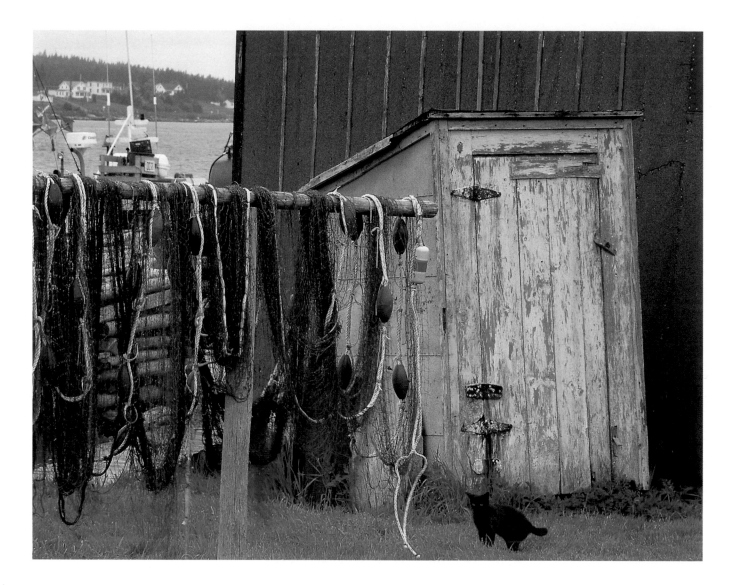

This one's the cat's meow.

It's high tide you got outa there! ▷

(*overleaf*) Slowly, silently now the moon
walks the night in her silver shoon.
— *Walter de la Mare*

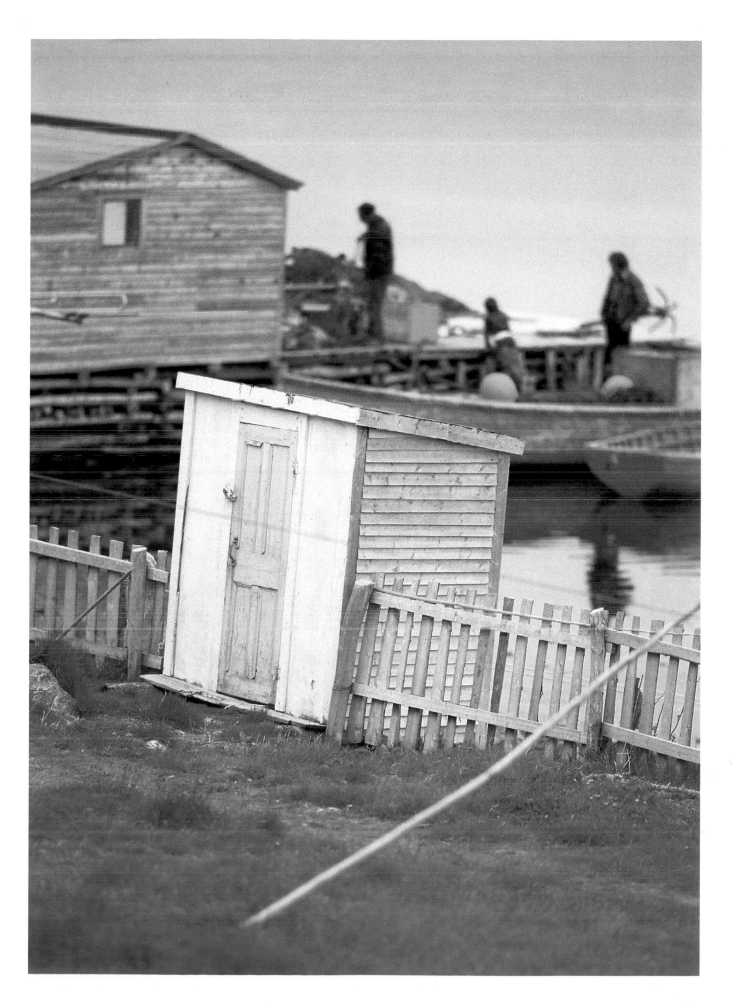

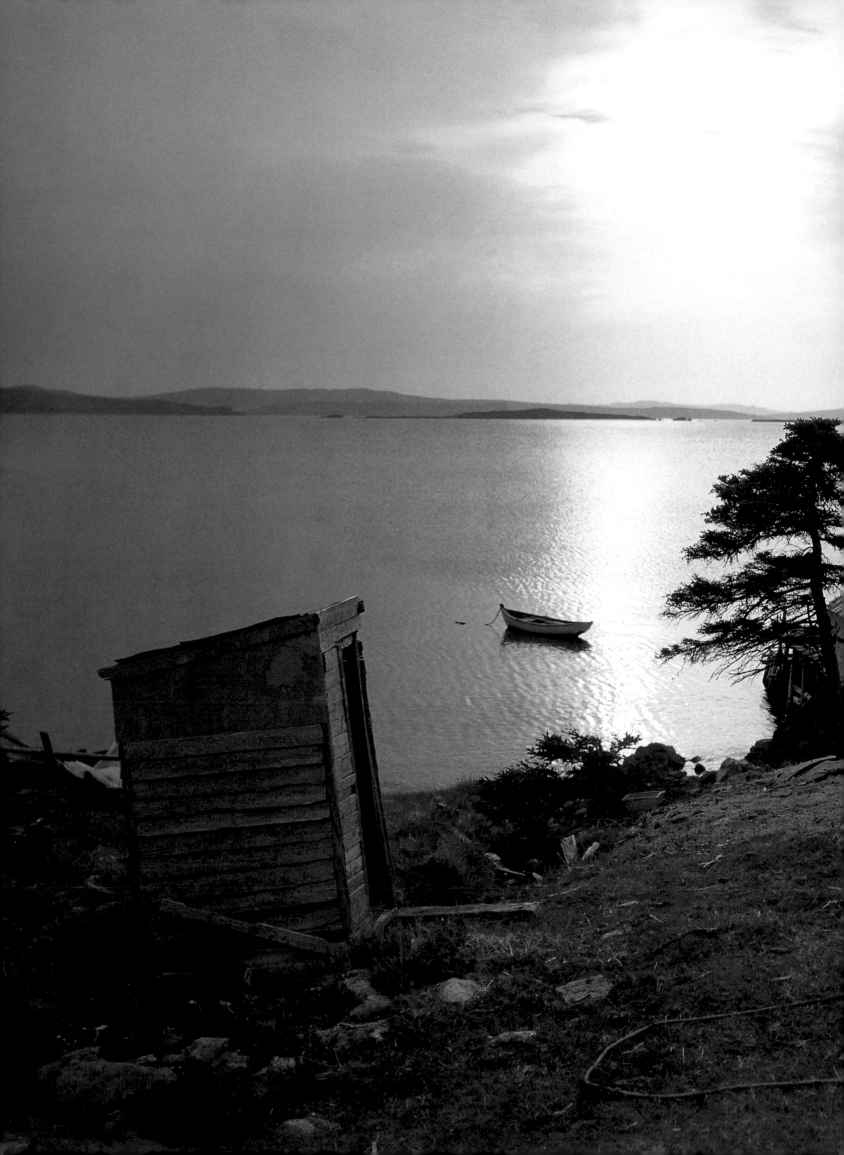

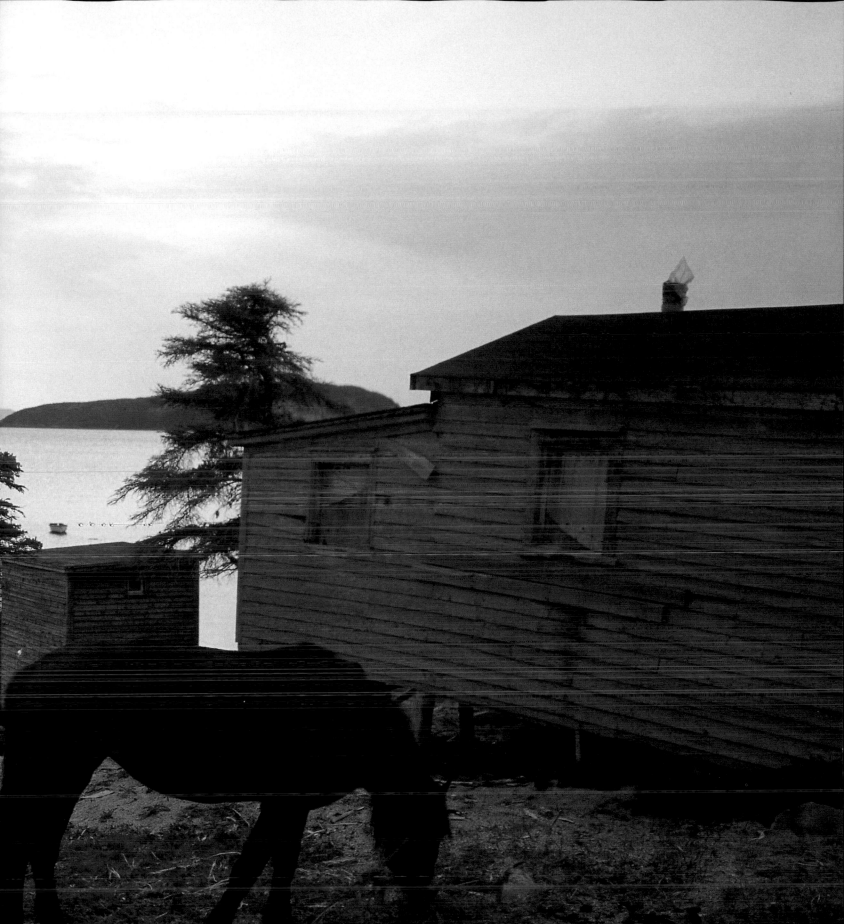

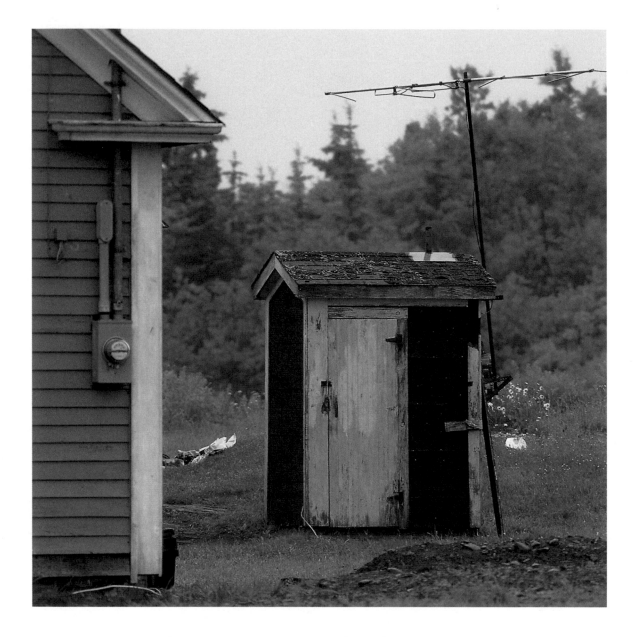

I hate to miss a minute of my favorite show
so I put the old set out here.

57 channels and nothin' on! ▷

(overleaf) I never found that companion
that was so companionable as solitude.
— *Henry David Thoreau*

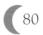

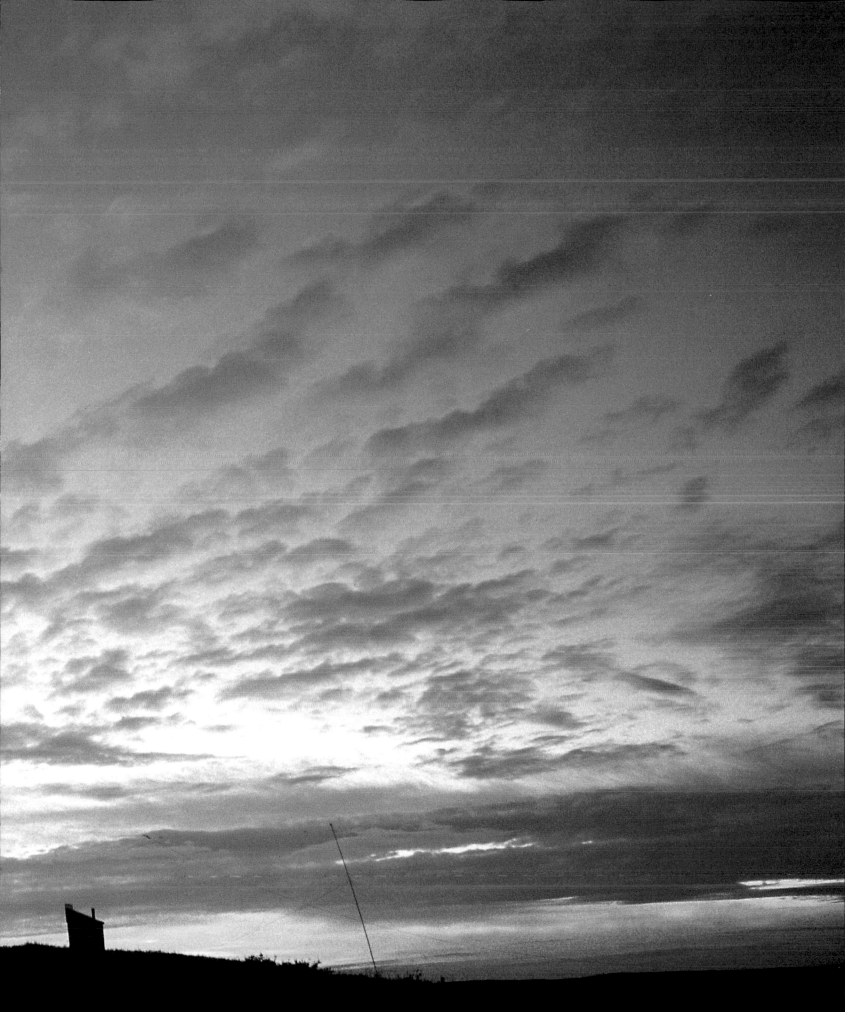

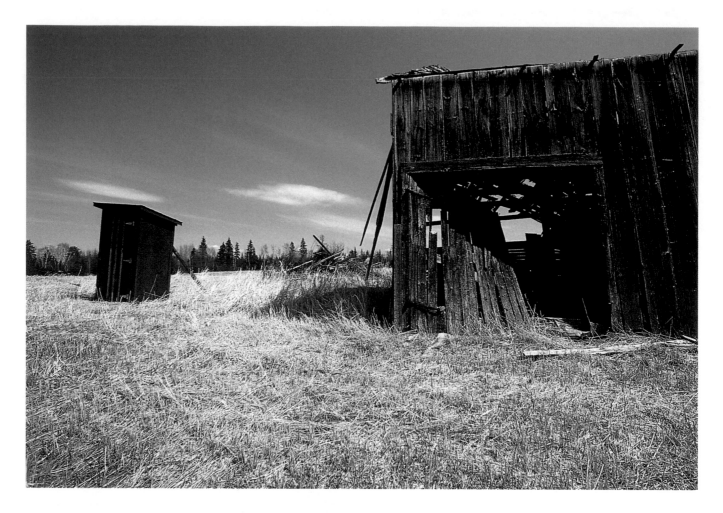

Stands (with a little help) the test of time.

The leaves have had their ▷
turn, now it's mine.

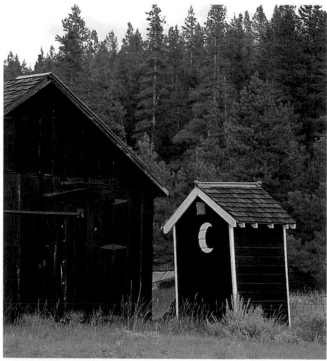

It's only a painted moon.

(*overleaf*) Revisited, the barns were gone
but there it was, in all its dignity,
dependable, majestic and waiting.

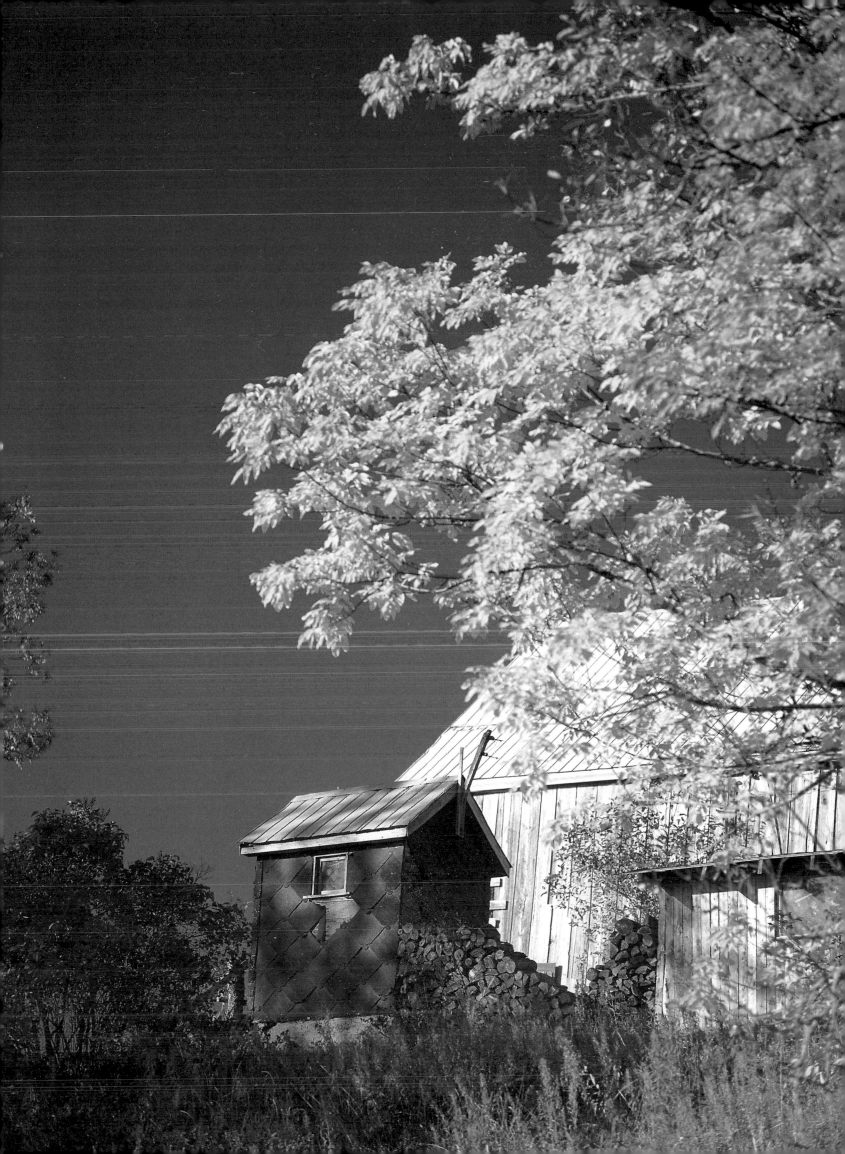

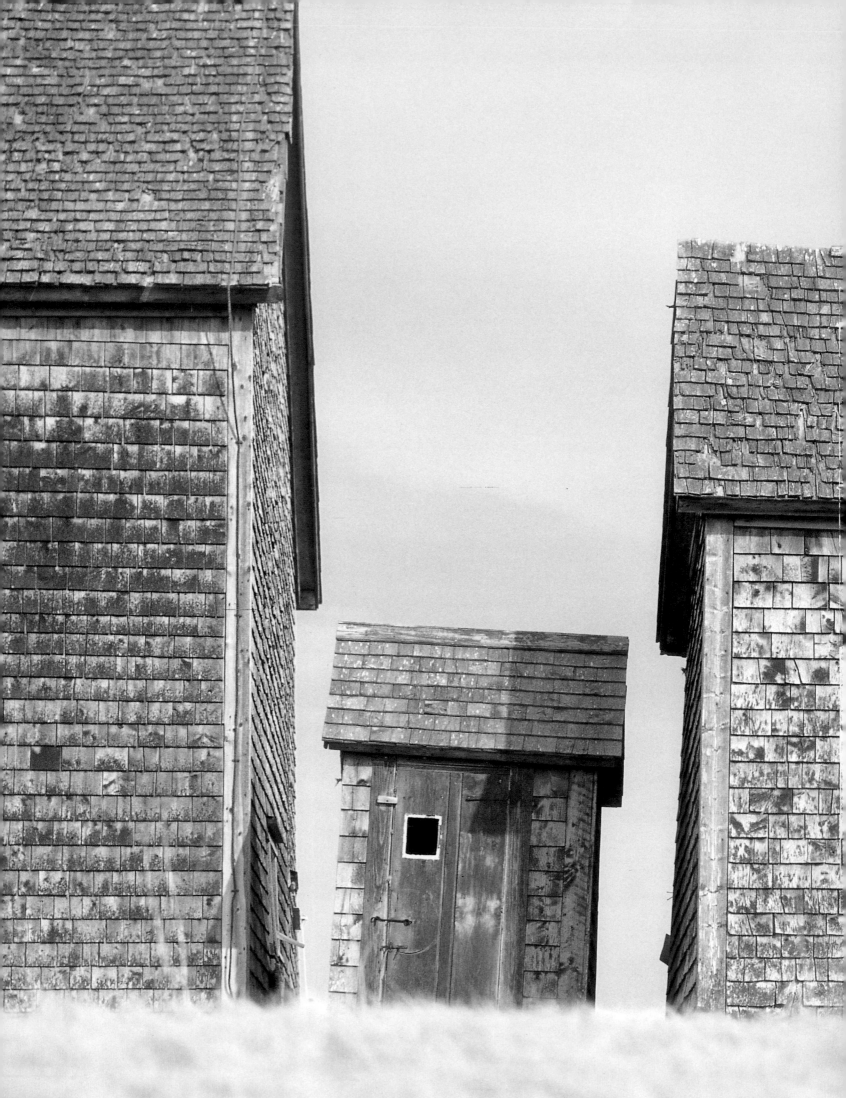

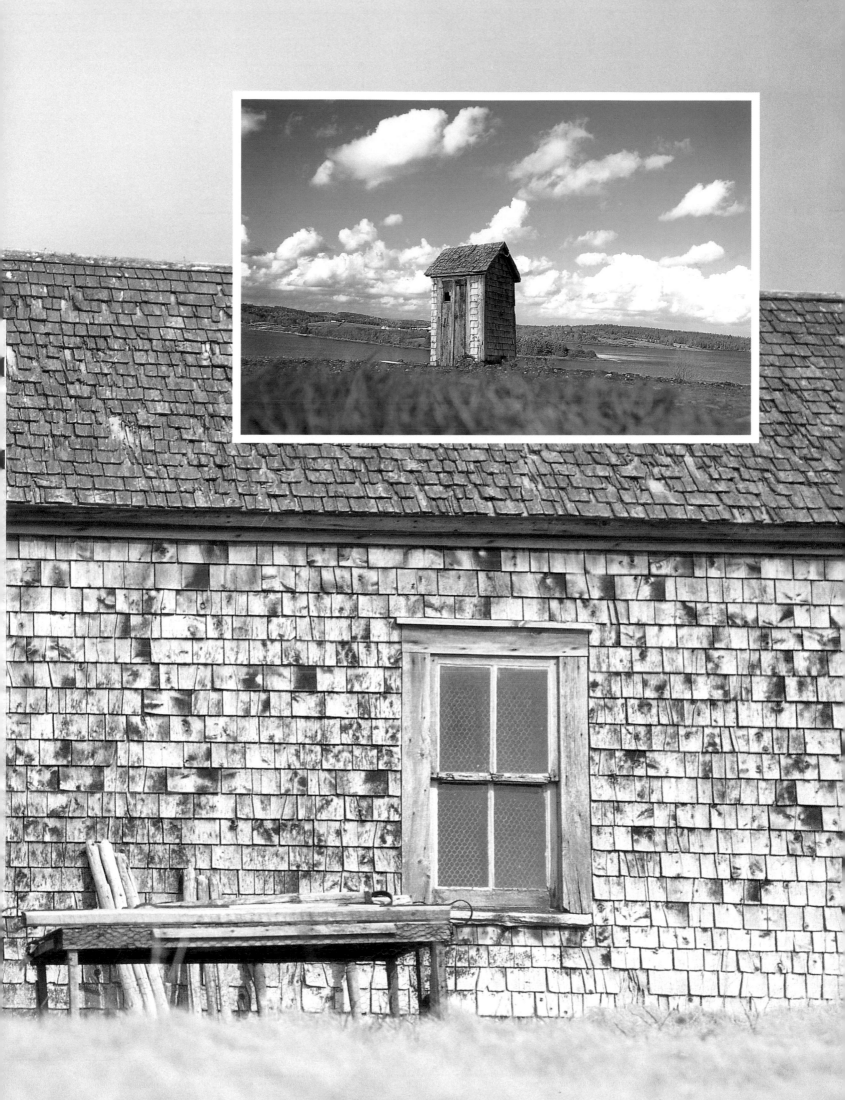

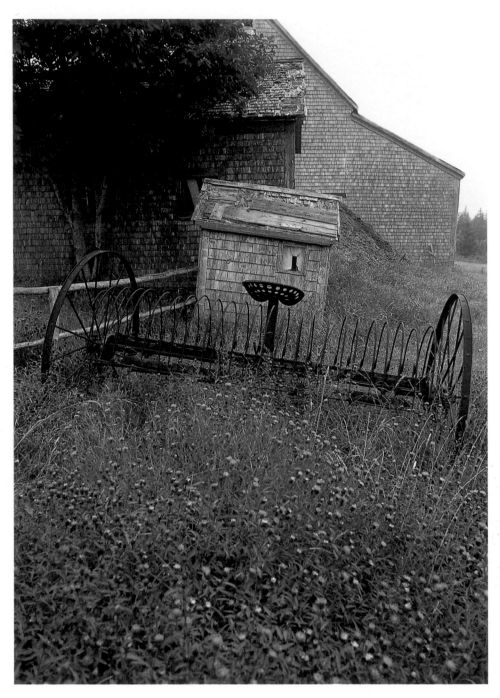

Hay rake, get out of my way!

Ever wonder why the dandelions grow so well around here? ▷

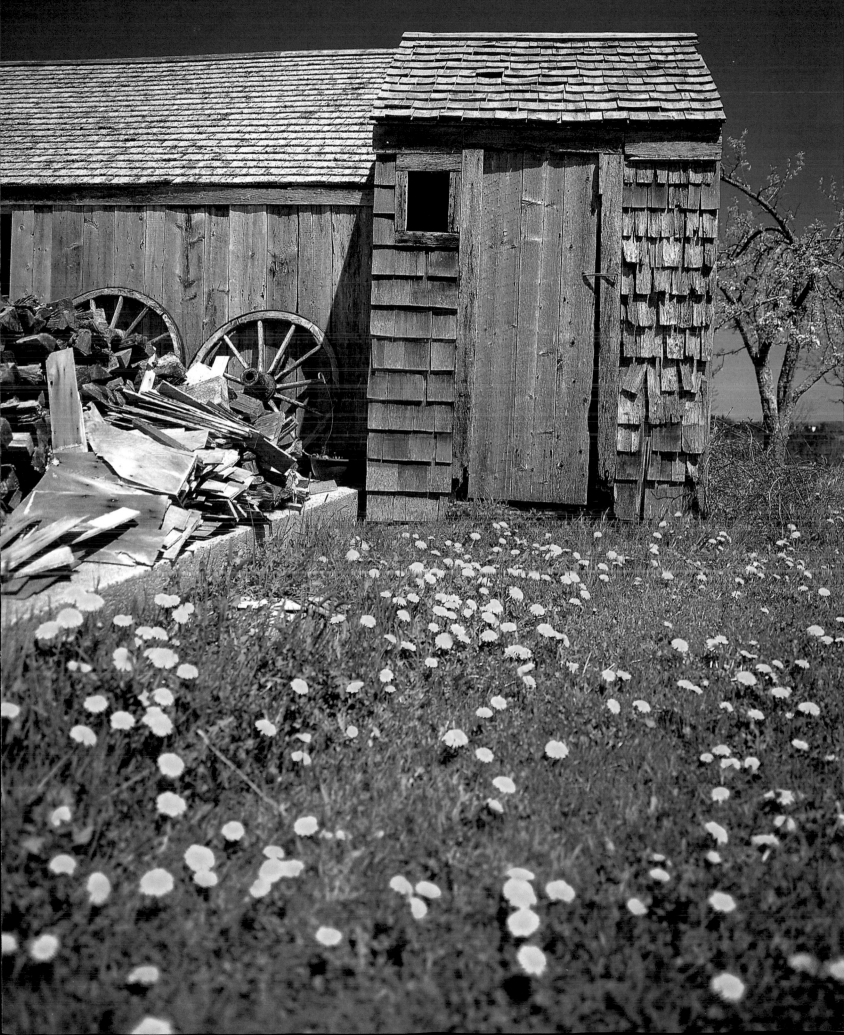

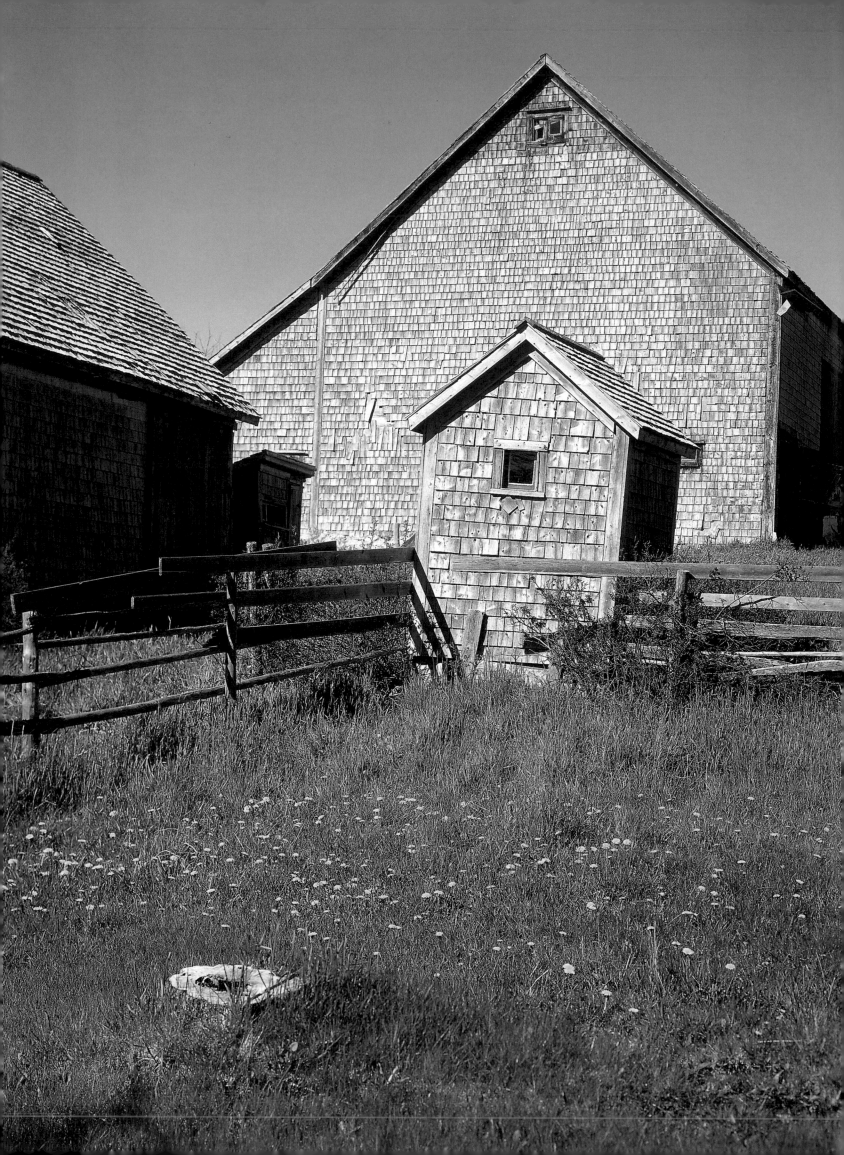

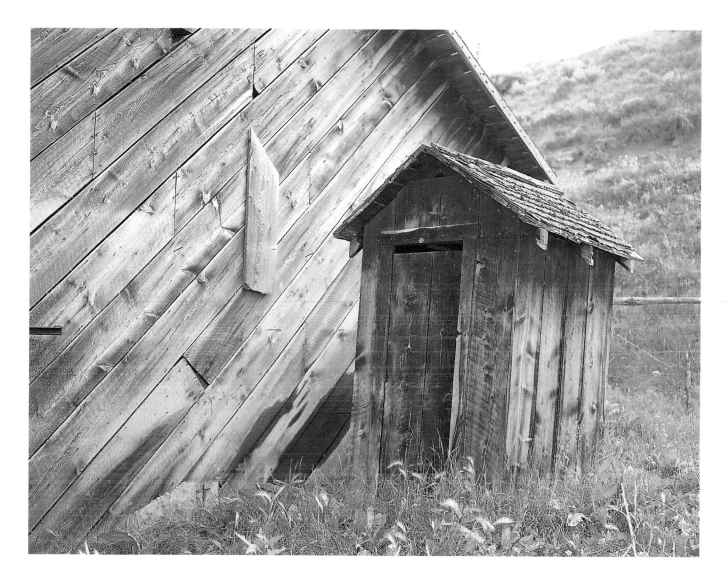

A little leaning is a dangerous thing.

◁ I had a case of shingles, so here's what I done.

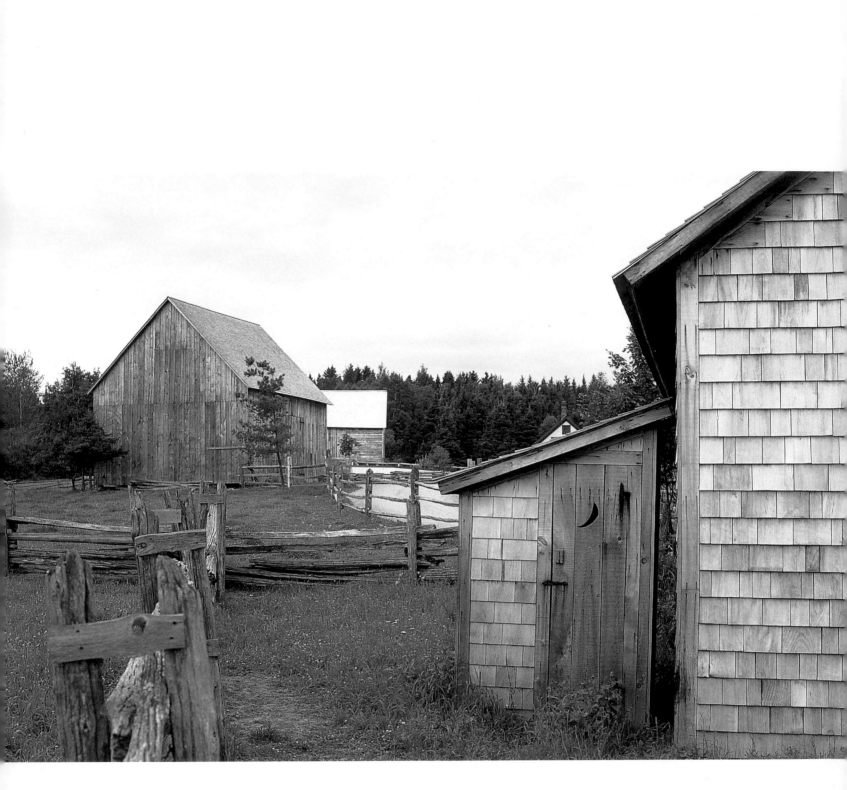

A little house well-filled – a little field well-tilled – are great riches.
– *Benjamin Franklin*

An in-house, outhouse! ▷

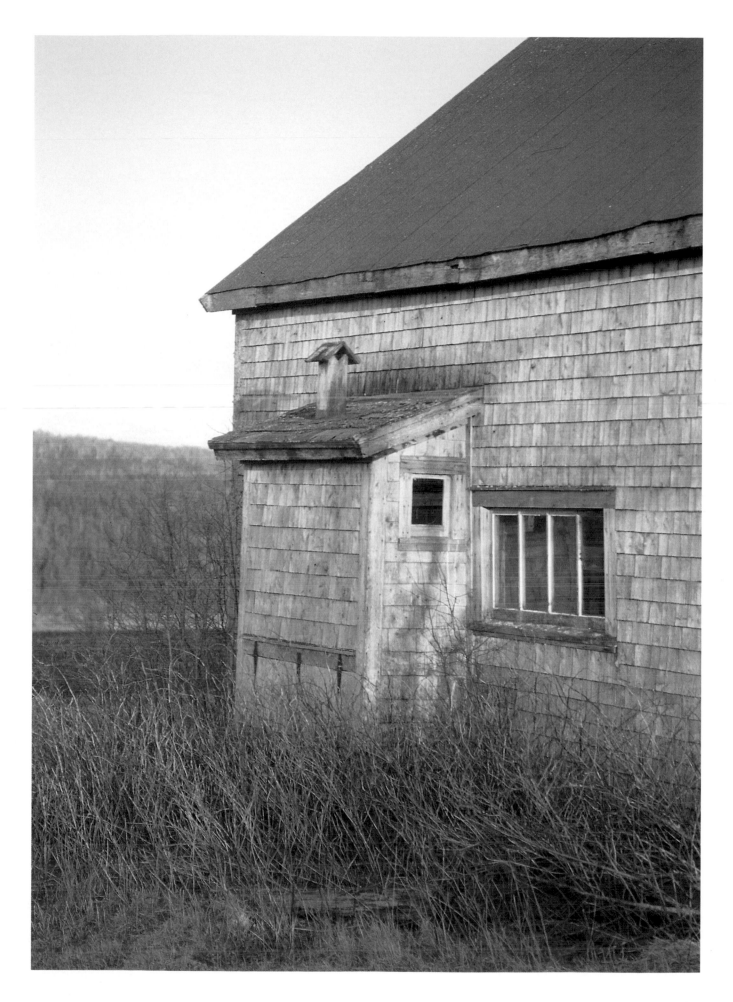

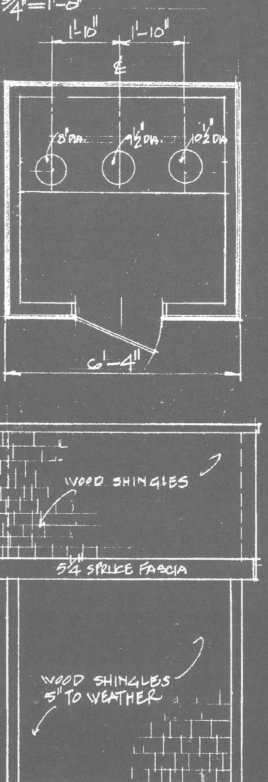

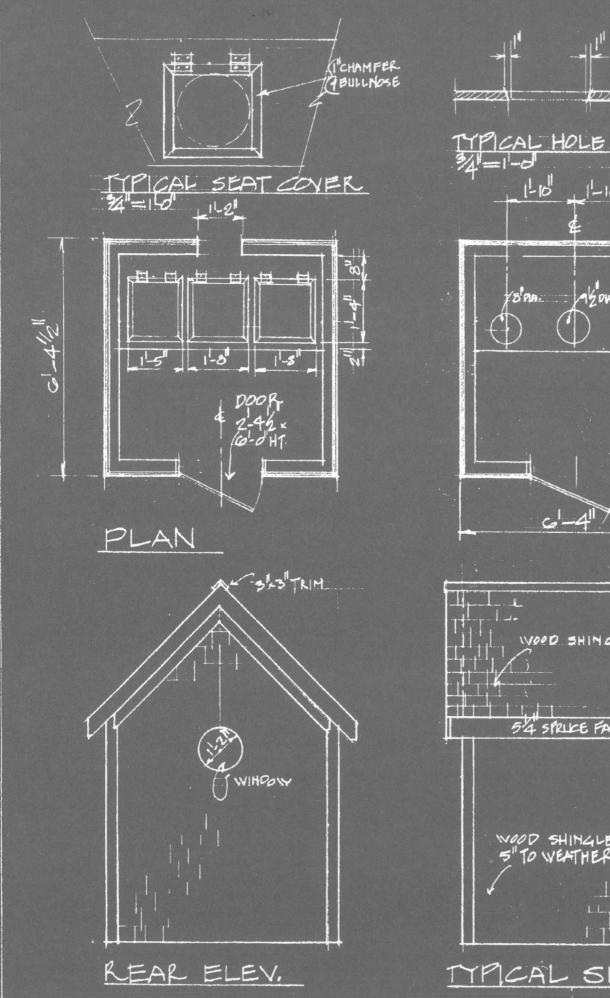

1"CHAMFER & BULLNOSE

TYPICAL SEAT COVER
¾"=1'-0"

TYPICAL HOLE
¾"=1'-0"

1'-2"

8"

1'-4"

2"

1'-5" 1'-8" 1'-8"

6'-4½"

DOOR
2'-4½" ×
6'-0" HT.

PLAN

1'-10" 1'-10"

₵

8"DIA. 9½"DIA. 10½"DIA.

6'-4"

3"×3" TRIM

1'-2"

WINDOW

REAR ELEV.

WOOD SHINGLES

5/4 SPRUCE FASCIA

WOOD SHINGLES
5" TO WEATHER

TYPICAL SIDE ELEV.